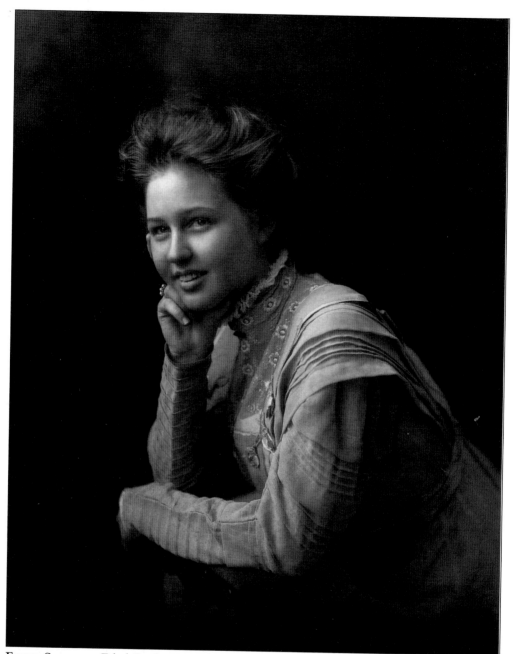

ETHEL STERLING. Ethel Sterling was the first president of the Delray (before Delray Beach) Historical Society. The daughter of Henry Sterling, who came to Delray in 1896, she is pictured here in 1910 at the age of 18 years. She died at the age of 95 in 1987 and is the grandmother of William S., Carl T., and Anne T. Williams of Palm Beach and Broward Counties. (Courtesy of Williams S. Williams, Esq.)

IMAGES
of America

DELRAY BEACH

McCall Credle-Rosenthal

ARCADIA
PUBLISHING

Published by Arcadia Publishing
Charleston, South Carolina

Printed in the United States of America

Library of Congress Catalog Card Number: 2003109046

For all general information contact Arcadia Publishing at:
Telephone 843-853-2070
Fax 843-853-0044
E-mail sales@arcadiapublishing.com
For customer service and orders:
Toll-Free 1-888-313-2665

Visit us on the Internet at www.arcadiapublishing.com

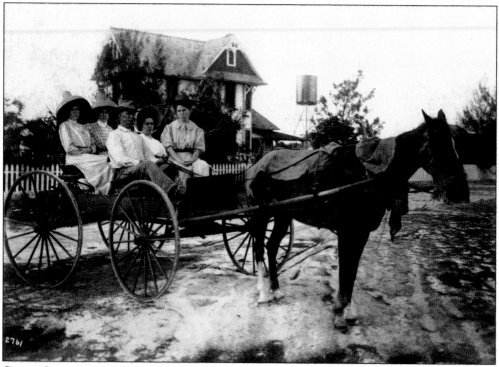

GROUP LEAVING THE SUNDY HOUSE ON S. SWINTON AVENUE. After a trip to the packing-house on the edge of town, this group poses for a photograph. (Courtesy of Delray Beach Historical Society.)

CONTENTS

ACKNOWLEDGMENTS

My fascination with historical events and buildings led me to accept an invitation by Glenn Weiss, director of the Cultural Loop & Artwalk Project of Delray Beach, to author this book. My enchantment with the settlers, those who were already here, and the pioneers who came with Congressman Linton from Bay City and Delray, Michigan, as well as the stories of their descendants and relatives of today, expressed to me through words and photos, held me captive. Fortunately for me, through the auspices of the Delray Beach Historical Society's Harriet W. and George D. Cornell Archives Room in the Cornel Museum at Old School Square, citizens of Delray Beach have complete access to the archives of the society. Since 1964 archives have been preserved documenting the history of Delray Beach. With the enthusiastic spirit and cooperation of archivist Dorothy Patterson of the Delray Beach Historical Society, this book has unfolded.

Being able to deliver more of the storytelling of the elders will take another book. There are numerous people whom I would like to thank for their technical and photographic assistance, personal images, and sharing of stories as researchers, descendants, and relatives of many of the people reflected in this book. Finally I would like to thank this "Village by the Sea," as it is often referred to, for its mystical charm that captivated my interest enough to make me a resident.

Thank you to:

Dharma Holdings, Ltd.
Delray Beach Historical Society
Delray Beach Playhouse
Mim George
Pat Healy-Golembe
Greater Delray Beach Chamber of Commerce
Mary Lou and Sandy Jamison
Thomas Kemp
Fran Marincola
Art Nejame
Old School Square Cultural Arts Center
Ruth Pompey
Vicente Martinez
John and Marcia Miller
Tamelyn "Tammy" Sickle
Alexander "Sandy" Simon
Ernest "Ernie" Simon, Esq.
Ross & Virginia Snyder
S.D. Spady Cultural Arts Museum
Elizabeth Wesley
Michael Weiner, Esq.
William S. Williams, Esq.

INTRODUCTION

Delray Beach, located in Palm Beach County with a population of approximately 62,000, lies 20 minutes south of Palm Beach and 50 miles north of Miami. Often referred to as "The Village By the Sea," farming had been its main industry, though now service and retail trade have become the main source of income for its residents. Nestled between the sea-grape vegetation on the Atlantic Ocean and farmland on the west, this quaint, charming city continues to have the same vibrant spirit as it had in the early 1900s, with its festivals and carnivals on Main Street, now known as Atlantic Avenue.

Vast farmland attracted people here from the Bahamas and other nearby Southern states to work in the fields by 1894, when Michigan congressman W.S. Linton led a group of pioneers traveling on Henry Flagler's Florida East Coast Railway as far as West Palm Beach. They arrived in Delray Beach by barge. Linton and the Model Land Company named the town Linton in 1895. According to the United States Post Office archives, Linton was renamed Delray (after a town in Michigan by the same name) in 1897 to erase memories of unsuccessful financial speculations and a bad farming season. In 1911, the town was incorporated as Delray; in 1927, it was incorporated as Delray Beach. The endurance, strength, and courage of the diverse population of black settlers and white pioneers enabled them to overcome many hardships. A small group of Japanese farmers along with the Seminole Indians already here contributed to change and progress.

By 1896, the FEC railroad facilitated the shipment of vegetables and fruit to the north. The famous Florida real estate boom started attracting people to Delray Beach around 1924. Mesmerized by the fun and comfort of this beach community, the people in the arts flocked to Delray Beach in the 1920s and continued to come through the 1950s. Delray Beach was known as a haven for artists and writers. Many nationally known cartoonists and writers made Delray Beach a seasonal destination and eventually made this artsy, sleepy town a permanent residence. The town was known as "The Artists and Writers Colony." Many of the events of World War II were recorded in the drawings of well-known cartoonist Herb Roth for the *Delray News*.

Delray has a rich and diverse architectural history, and through perseverance, many of the historic structures have been protected. While much of the country was feeling the impact of the Depression, many buildings were constructed in the "golden age" of Delray Beach architecture, 1927–1940, and have been preserved. In the 1950s, Delray Beach struggled with the civil rights of African Americans and their desire to swim at the local beach and swimming pool. It was a period of growth for Delray Beach on many levels. Gladiolas sprung up as a major industry during that time, celebrated with Gladiola Festival parades.

By the 1970s Delray Beach was experiencing rapid population growth; however less of its architectural integrity had been compromised than in some of the neighboring cities. By the late 1980s, and continuing today, historical appreciation and commercial vision have given downtown Delray Beach a vibrant merchant and pedestrian ambiance. Considered the best-run city in Florida in 1995 by the business publication *Florida Trend*, Delray Beach was also bestowed the honor of being named an "All-America City" in 1993 and 2001 by the National Civic League. The festive celebrations continue. The Delray Affair has replaced the Gladiola Festivals of the 1950s. The parades continue and the lively atmosphere of the street carnivals

on Atlantic Avenue in the early 1900s has taken on the form of art festivals. Jazz on the Avenue and other street-related events, generated by the local merchants, restaurant owners, and artists attracts thousands to Delray Beach, thus sustaining tourism and its important role in the city's economic base. Delray Beach continues to be a haven for artists and writers who come to display their talents at the annual festivals and local museums. Local authors and poets are known locally and nationally.

As I write, the Delray Beach Cultural Loop project is evolving, serving as a 1.3-mile historical path connecting cultural institutions, businesses, churches, and people. Linked into this Cultural Loop is the Pineapple Grove Artwalk, a walking gallery display of sculptures within the boundaries of the walking trails of this historical path. Today, in the western part of Delray Beach, the cucumbers and peppers have replaced the pineapples and gladiolas, with Delray Beach ranking fifth on the list of vegetable growers in Florida. Diverse groups representing city government, and civic, cultural, business, and social arenas are all involved in the trend to continue keeping Delray Beach's character, integrity, and quality-of-living standards.

Many of the early settlers and pioneers who ventured here have left a legacy of stories with relatives and friends. With regret, I could not use more of the images and the themes that availed themselves to me, hence another book is required. I have tried to give locations whenever possible to give one the vision of the "before." Perhaps the vision of how things were will generate respect for those who suffered through the most adverse conditions in the late 1800s and early 1900s, and earn our gratitude for their impact on our "today."

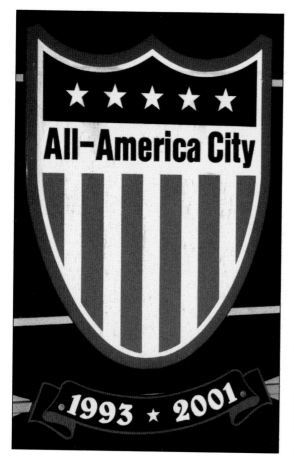

ALL AMERICA CITY. Delray Beach won the prestigious "All America City" award in 1993 and 2001. In 1993, Delray Beach was bestowed this national ward for its charming downtown restoration and vibrancy. In 2001, the city was honored with this award again, this time for the altruistic programs that have enhanced the lives of the Delray Beach youth, low-income senior citizens, and the Village Academy students and families. (Courtesy of Art Nejame.)

One

AGRICULTURE

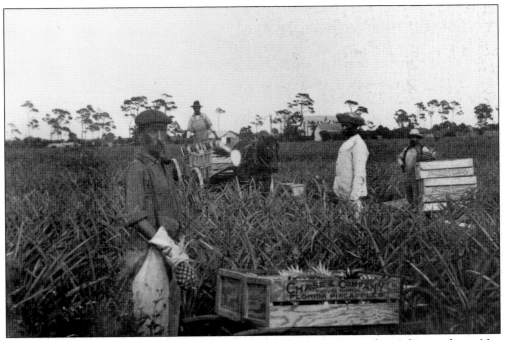

ADOLF HOFMAN'S PINEAPPLE FIELDS, c. 1905. Workers pick pineapples and crate them. Notice that the field hands wore heavy gloves and protective clothing to handle the pineapples. Mr. Hofman is on the far right. This is an area that is now N.E. 7th Avenue and the Intracoastal Canal. (Courtesy of Delray Beach Historical Society.)

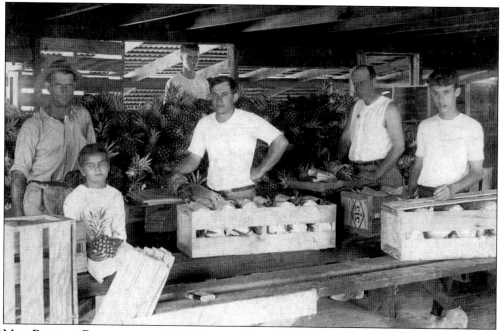

MEN PACKING PINEAPPLES, C. 1910. Farmers found that pineapples grown in Delray were of exceptional quality. (Courtesy of Delray Beach Historical Society.)

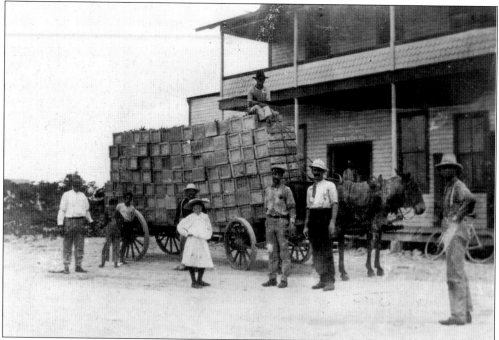

PINEAPPLES READIED FOR SHIPPING. Here pineapples are crated and readied for shipment by Chase & Company on a wagon in front of McRae's store, built in 1902. The McRae family lived upstairs. The general store downstairs was run by Mrs. McRae, and T.M. McRae operated the adjoining pharmacy. Powers Lounge eventually replaced the building. The location is Atlantic Avenue and today's railroad tracks. (Courtesy of Delray Beach Historical Society.)

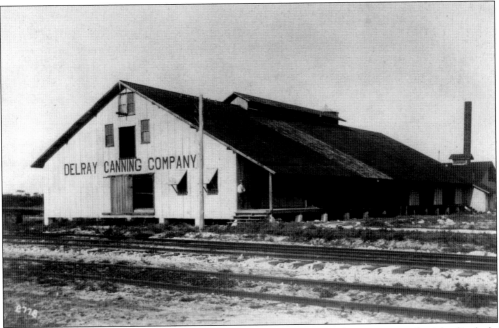

DELRAY CANNING COMPANY. In 1904, the pineapple-canning factory opened with the help of Henry Flagler. The whole town turned out to celebrate. An orchestra hired from Miami entertained enthusiastic guests as the temperature began to drop and the freeze set in. Unfortunately, there were many losses. The Delray Canning Company was located east of the railroad tracks, just north of Atlantic Avenue. (Courtesy of Delray Beach Historical Society.)

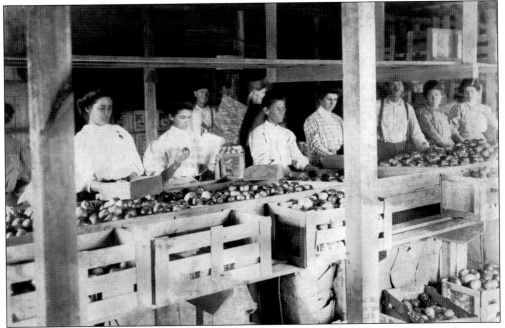

PACKING TOMATOES, c. 1910. These women are shown packing tomatoes. After they were wrapped in thin paper, they were placed in boxes shipped north. Agriculture was the main industry in Delray. (Courtesy of Delray Beach Historical Society.)

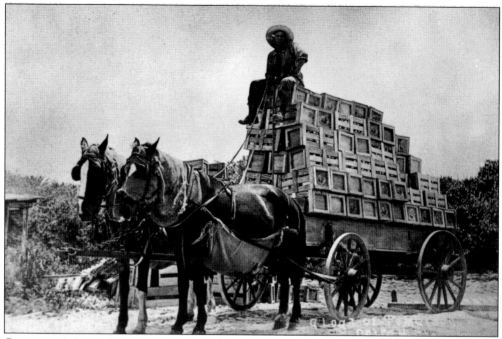

CRATED TOMATOES, C. 1905. Tomatoes are loaded on a wagon ready for shipment via railroad by Chase & Company. Since there were not many horses, those that did live in the area were protected from flies and mosquitoes with burlap, soaked in creosote. The welfare of the horses was very important. (Courtesy of Delray Beach Historical Society.)

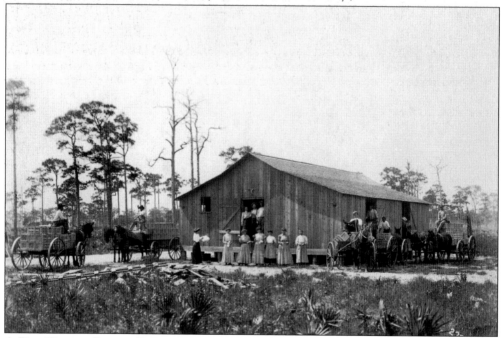

A DAY TRIP TO SEE THE PACKINGHOUSES ON THE EDGE OF TOWN, C. 1910. A favorite family outing on Sundays was a wagon ride to the packing houses. The early settlers found ways to have gatherings. (Courtesy of Delray Beach Historical Society.)

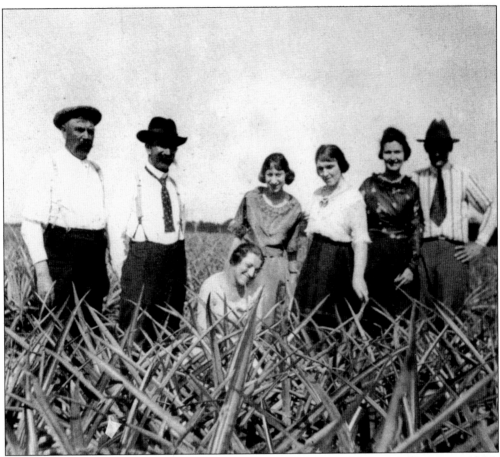

STANDING IN ADOLF HOFMAN'S PINEAPPLE FIELDS NEAR DIXIE HIGHWAY, FEBRUARY 1921.
Adolph Hofman, second from left, and Annie his daughter, second from right, are seen in this
photograph. Pineapples were a main source of income for Delray Beach. (Courtesy of Delray
Beach Historical Society.)

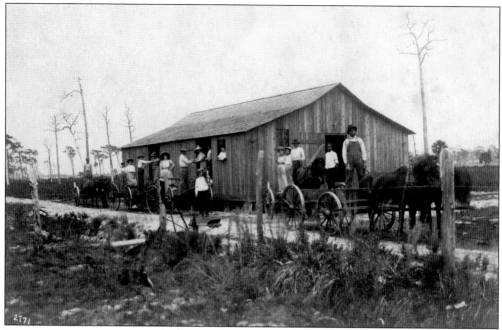

PACKING HOUSE WITH WAGON TEAM, C. 1910. Pineapples were replaced by tomatoes, cabbages, and other vegetables, due to blight and competition with Cuba. Shown here are a group in front of a packing house, preparing to ship their harvest north.

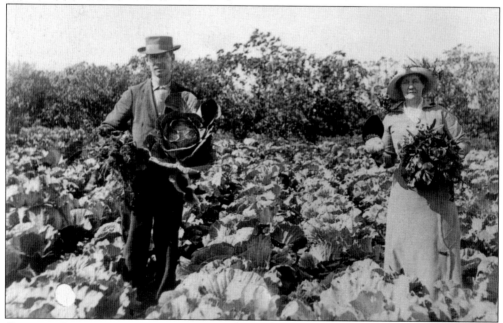

CABBAGE CROPS, C. 1910. Henry Sterling is seen on the left with an unidentified woman. Henry Sterling was posing for an advertisement for a promotional picture on an agriculture advertisement. Farming was a principal industry. Mr. Sterling's descendants live in Palm Beach County today. (Courtesy of Delray Beach Historical Society.)

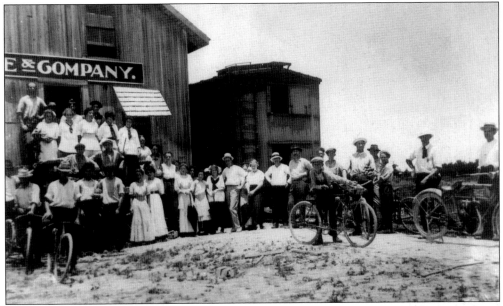

DELRAY PACKING COMPANY, C. 1903. People here are lined up outside a building near railroad tracks. Many of the early settlers came from Michigan, and the town was renamed after Delray, Michigan, in 1897 according to the United States Post Office archives, but it was still referred to as Linton for a few years. (Courtesy of Delray Beach Historical Society.)

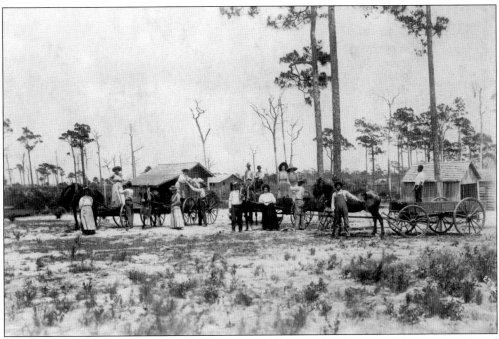

A WAGON TRAIN GATHERING, C. 1910. These wagons were used for hauling produce to and from the packinghouses. It appears that some of the ladies on the tour are posing by and in the wagons for the photographer. A large percentage of men who drove the teams were African American. (Courtesy of Delray Beach Historical Society.)

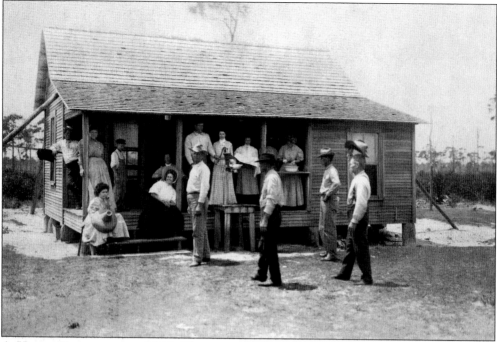

A HOUSE GATHERING, C. 1910. This is another series of photographs of the "tour" of the packinghouses. (Courtesy of Delray Beach Historical Society.)

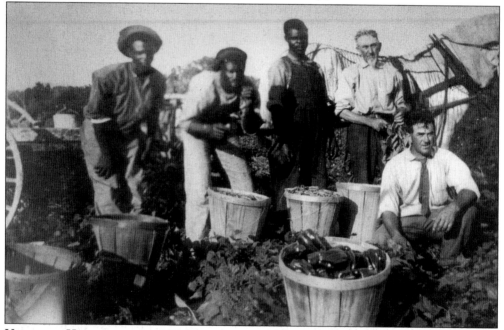

VEGETABLE HARVESTING. C. 1905. This photo was taken for a booklet showing that Delray was a farming area. It shows five men with hampers of green beans and peppers. This depicts the way of life for most of the men who arrived early in Delray. The man kneeling has been identified as Mr. Bradshaw, but not the same Bradshaw who built the Kentucky House. (Courtesy of Delray Beach Historical Society.)

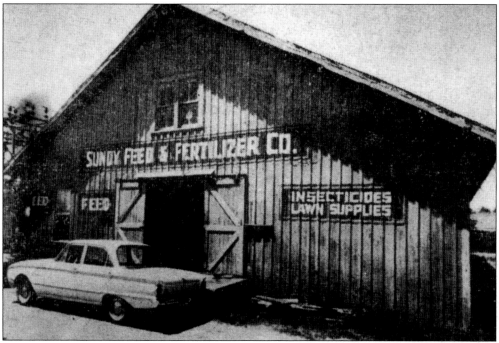

SUNDY FEED STORE. The Sundy Feed Store address was 36 N. Railroad Way. This was one of the most important stores in Delray. It supplied the agriculture industry for many years. The store was established in 1914 and survived until 1960. The building was moved to the Morikami Museum in the early 1990s. The site of the restored FEC Railroad Station is now at 36 Railroad Way. The Sundy Feed Store was moved to the South Florida Fairgrounds. (Courtesy of Delray Beach Historical Society.)

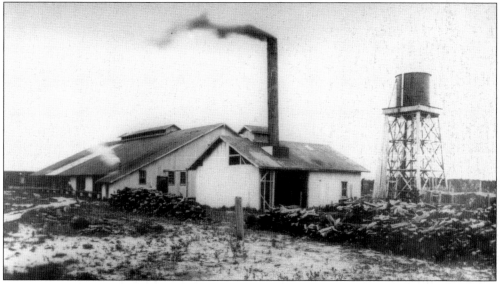

DELRAY CANNING COMPANY, C. 1905. This back view shows a large supply of wood and a water tower in the foreground, which were essentials for making ketchup. A windmill was used to supply the water tank. This location is N.E. 2nd Street at 4th Avenue. (Courtesy of Delray Beach Historical Society.)

WATER'S TRUCK FARM. C. 1917. Located between Ocean Boulevard and the Intracoastal Canal, Water's Truck Farm was 100 feet south of Water's House on Thomas Street. The five-acre farm produced strawberries. (Courtesy of Delray Beach Historical Society.)

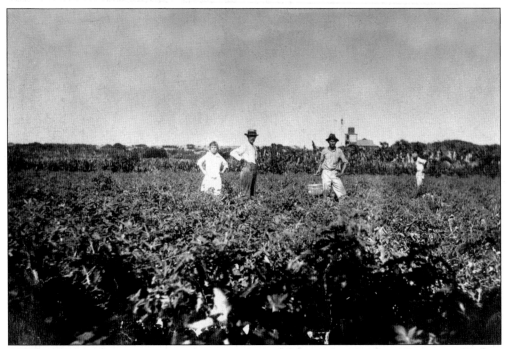

WATER'S TRUCK FARM. C. 1917. This scene depicts farming strawberries. (Courtesy of Delray Beach Historical Society.)

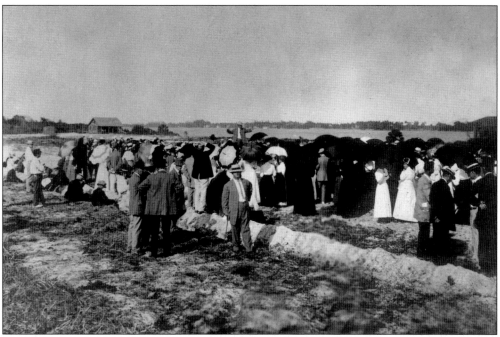

LAND SALE, C. 1910. Here people gather in a field and wait for a land sale to begin. Congressman W.S. Linton recorded a map and named the town Linton. In 1897 the town was renamed after a town in Delray, Michigan. (Courtesy of Delray Beach Historical Society.)

THE MAN HOLDING THE COCONUT IS CHARLIE ARMBUSTER. The couple may be the Betzes who had a farm on the boundary between Delray and Boynton. (Courtesy of Delray Beach Historical Society.)

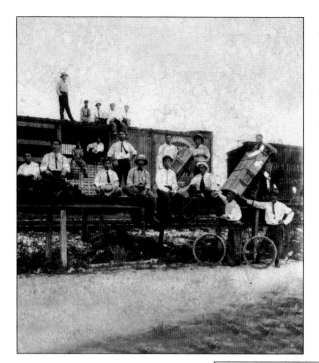

JAPANESE SETTLERS, c. 1926. Here some Japanese workers loading produce into Atlantic Coast Line and Seaboard railroad boxcars. The Japanese farming colony was called Yamato and was about halfway between Delray and Boca Raton. The Japanese settlers took part in the social and civic life of Delray Beach and were very successful in growing vegetables. (Courtesy of Delray Beach Historical Society.)

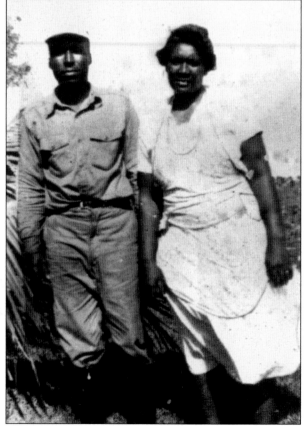

CHARLES AND ESSIE MAE MASSENGIL, PICTURED IN THEIR GLADIOLA FIELDS IN 1954. Mr. Massengil came to Delray Beach in 1939. In 1951, he started working for Everglades Flower Growers and became partners with Roy J. Polatta. In 1964 he bought the farm from Roy Polatta and experienced success until 1973. He is retired and continues to live in Delray Beach. (Courtesy of Delray Beach Historical Society.)

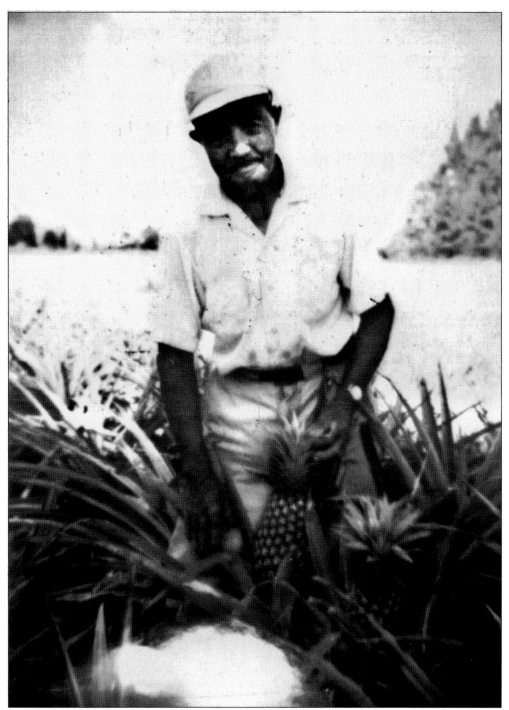

GEORGE MORIKAMI CULTIVATED PINEAPPLES. George Morikami moved to Florida in 1904. He joined the Yamato Colony of Japanese farmers who settled in what is now Boca Raton. He donated the land where the Morikami Museum and Japanese Gardens opened in 1977. His last legacy interprets Japanese culture for the western world. It is the only museum of its kind in the United States. (Courtesy of Virginia Snyder.)

DATES IN HISTORY

1868—Capt. George Gleason, son of William H. Gleason, bought acreage comprising what is now part of Delray Beach at a price of $1.25 per acre.

1876—Hannibel Dillingham Pierce was appointed first keeper of the House of Refuge, a United States Coast Guard rescue station located two blocks north of Atlantic Avenue on N. Ocean Blvd.

1885—Mail service by the "barefoot mailman" began between Juno and what is now known as north Palm Beach County and Miami.

1890—The East Coast Canal (Intracoastal Waterway) was made navigable to the House of Refuge area.

1894—William A. Linton, then postmaster of Saginaw, Michigan, asked his close friend David Swinton to join him on a safari to Florida by barge down the Intracoastal Canal. Linton bought 160 acres of land at $25 per acre with the backing of Swinton. Linton also made a down payment on 640 acres.

1895—Linton brought a small band of followers, including E. Burslem Thomson, a civil engineer; W.W. Blackmer, a railroad clerk; Frank W. Chapman, a supply agent for Michigan Central Railroad; and five farmers, Jason Baker, Peter Leurs, Otto Schrader, Kemp Burton, and Adolph Hofman. Linton and Thomson and the civil engineers lay out the town of Linton.

1896—The first passenger train arrives in Linton by Florida East Coast Railway.

1896—Mt. Olive Church was organized.

1897—Henry Sterling and family came from Pennsylvania and started the first commissary. The farmers had started raising pineapples, tomatoes, green beans, peppers, and other vegetables. However, on February 6, 1896, a hard freeze destroyed all crops, and in despair many settlers left and returned to Michigan. Linton was unable to make payments on his land.

1897—The town's name of Linton is changed to the name to "Delray" after a Detroit suburb. W.W. Blackmer, the former railroad clerk, was appointed leader of the people who did not return to Michigan.

1897—Mt. Tabor, now the St. Paul African Methodist Episcopal Church, was organized.

1898—Linton's mortgages are foreclosed. A few of the people who remained here bought back the land.

1898—The first cultural event was held at the schoolhouse featuring the "Linton Glee Club."

1898—J.S. Sundy and family arrived.

1902—The first hotel was built by Frank W. Chapman. It was known as The Inn, then the Chapman House, and later The Grand Hotel.

1903—First Methodist Church and Rectory was built.

1904—Trinity Lutheran Church and St. Paul Episcopal Church are built and dedicated.

1908—Telephone service is established.

1910—The United States Census counts a population of 904.

1911—Town of Delray is incorporated with J.S. Sundy as mayor.

1913—A library is begun by the Ladies Improvement Association. "Doc" Love is appointed new postmaster. The *Delray Progress*, the first newspaper, is printed by Mrs. J.M. Cromer and Mrs. T.A. Tasker.

1914—Delray gets electricity.

1927—The town of Delray became Delray Beach. The area east of the Intracoastal had incorporated in 1923 as Delray Beach. After merging, the entire area became Delray Beach.

Two

ATLANTIC AVENUE

STREET BANNER ON ATLANTIC AVENUE. Banners and street lamps, reminiscent of Delray Beach of the past, were part of the city's revival efforts for Atlantic Avenue in the 1990s. (Courtesy of McCall Credle-Rosenthal.)

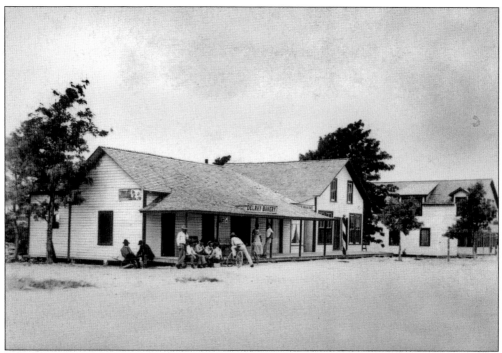

DELRAY BAKERY, ATLANTIC AVENUE, C. 1900. This is an early view of the bakery, a barbershop, and Sterling Commissary at the far right. (Courtesy of Delray Beach Historical Society.)

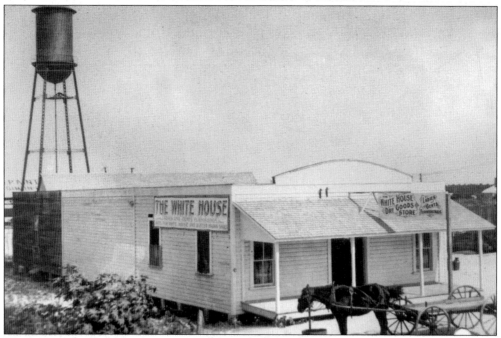

WHITE HOUSE DRY GOODS STORE, C. 1910. A horse and wagon are pictured in front of the store, which supplied apparel for "Ladies and Gents, furnishings and Buster Brown Shoes." (Courtesy of Delray Beach Historical Society.)

THE MILLER HOUSE, C. 1910. From left to right are Al Miller, Mary Clutter Miller, and Albert, father of Al Miller, who served as a councilman in the 1940s. Al opened a fishing tackle shop on Atlantic after retiring as a barber. (Courtesy of Marcia and John Miller.)

THE FIRST POST OFFICE, c. 1903. The first post office was located at E. Atlantic Avenue and 4th Avenue. Joel W. French was the postmaster and his wife operated the first gift shop in Delray in the same building, shown on the left with the novelty and drug sign. The estimated population of Linton, before it changed its name to Delray, was approximately 150. (Courtesy of Delray Beach Historical Society.)

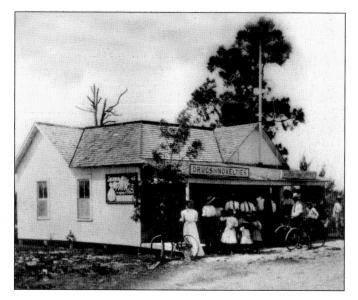

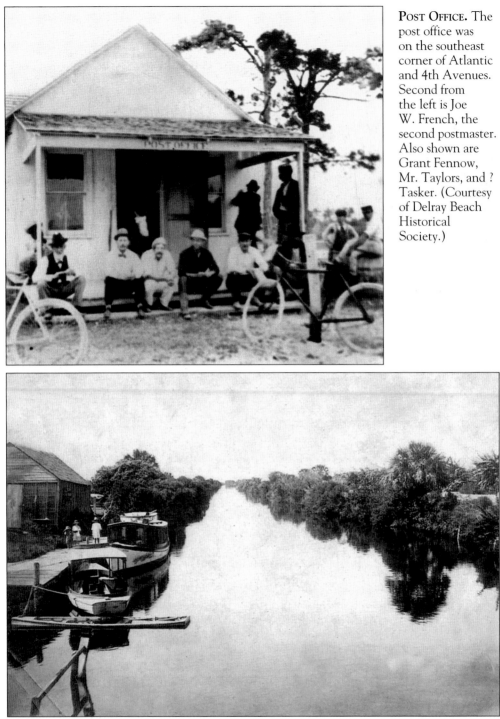

POST OFFICE. The post office was on the southeast corner of Atlantic and 4th Avenues. Second from the left is Joe W. French, the second postmaster. Also shown are Grant Fennow, Mr. Taylors, and ? Tasker. (Courtesy of Delray Beach Historical Society.)

THE CANAL, LOOKING NORTH, NOW KNOWN AS THE INTRACOASTAL, C. 1920. Before 1911, people preferred to take the boat to West Palm Beach for their banking rather than the train. In the early years of train service, one had to spend the night since there was only one train per day to West Palm Beach. (Courtesy of Mary Lou and Sandy Jamison.)

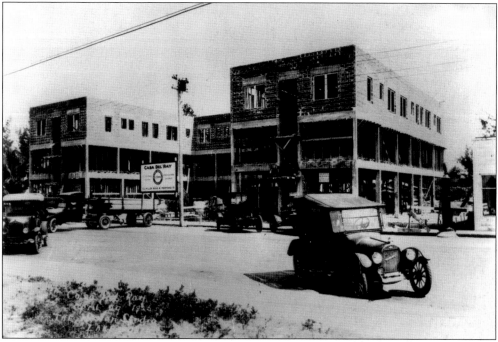

CASA DEL REY UNDER CONSTRUCTION. Built in 1925 by Henry Sterling, Casa Del Rey was known for its rooftop restaurant with a retractable roof. It was later called Bon Aire Hotel. It was in the location where Worthing Park is today. The auction of the furnishings of the Bon Aire, conducted by Robert "Bob" Worthing, was held in the late 1960s. (Courtesy of Delray Beach Historical Society.)

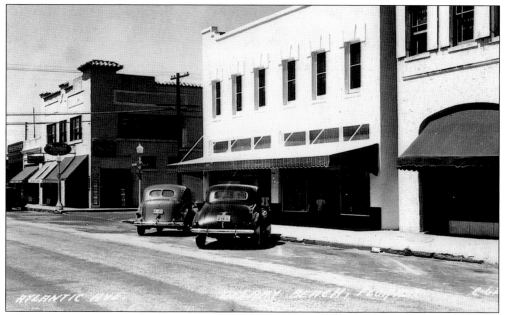

ATLANTIC AVENUE, C. 1937. The building on the left is Mercer Wenzel Department Store, which continues to operate on that same Atlantic-at-4th-Avenue location. (Courtesy of Marcia and John Miller.)

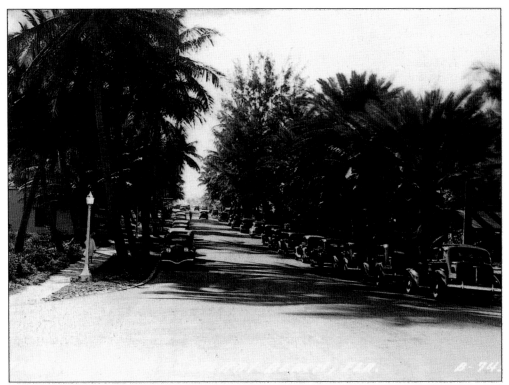

FROM BRIDGE TO DOWNTOWN, LOOKING WEST, C. 1940S. Gasoline was rationed after the war. In 1947 many of the palm trees that lined Atlantic Avenue, some of which are shown in this photograph, were destroyed by hurricanes. (Courtesy of Marcia and John Miller.)

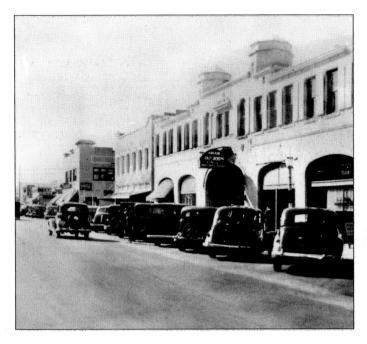

ARCADE BUILDING, c. 1930. The Arcade Building was on the 400 Block of East Atlantic Avenue (north side). This was the location of Arcade Tap Room, a favorite meeting place for members of the writers and artists colony of Delray Beach. The population of Delray in 1930 was 2,333. (Courtesy of Delray Beach Historical Society.)

MASONIC BUILDING.
The Masonic Building was located at 1st and Atlantic Avenues. The post office was located there from the 1920s through 1940s, and its entrance was on the S.E. 1st Avenue side. The Masonic Hall was on the second floor. (Courtesy of Delray Beach Historical Society.)

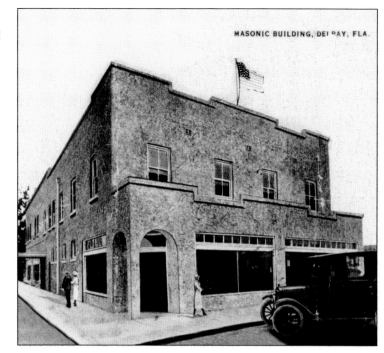

MASONIC BUILDING, DELRAY, FLA.

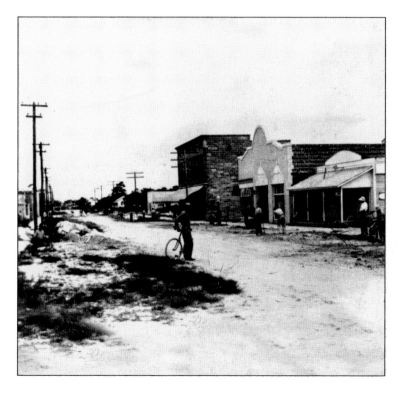

ATLANTIC AVENUE, LOOKING WEST, c. 1915–1920. This view was taken from Florida East Coast Railroad, looking west. Some of the stores and buildings shown are Harvel's Meat Market, O'Neal's Garage, and the Cathcart Building, which housed a drug store and doctor's offices on Atlantic and 2nd Avenues. (Courtesy of Delray Beach Historical Society.)

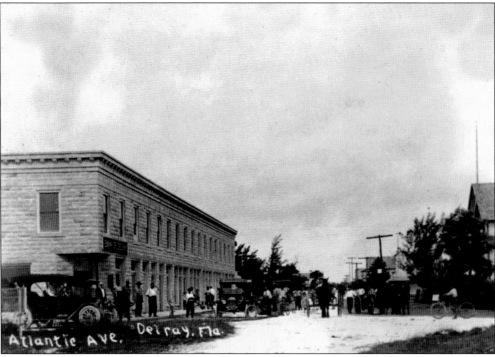

BANK OF DELRAY, C. 1915. A view of Atlantic Avenue shows the Bank of Delray, which was the first concrete building in Delray and called the Cromer Building. It was built around 1911 by J.M. Cromer at S.E. 5th Avenue and Atlantic Avenue. It is now the location of the popular Cheeburger eatery. (Courtesy of Delray Beach Historical Society.)

DELRAY BEACH, ATLANTIC AVENUE. This view looks east through a colonnade of Royal Palm trees, *c.* 1930. (Courtesy of Delray Beach Historical Society.)

WEST PALM BEACH, 17 MILES.
Clara Gehrs stands on rock showing
directions. (Courtesy of Delray
Beach Historical Society.)

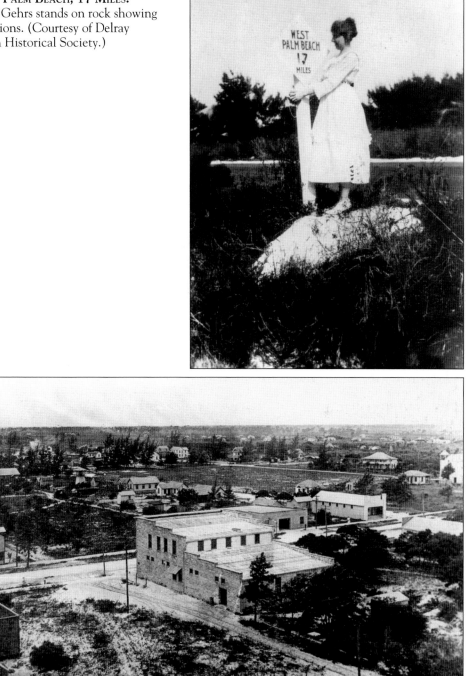

DELRAY BEACH, S.W. SECTION, c. 1915. This shot was probably taken from the water tower of the canning company. The large building in the foreground is the Cathcart Building, a good example of an early masonry vernacular building still surviving at N.E. 2nd and Atlantic Avenues. (Courtesy of Delray Beach Historical Society.)

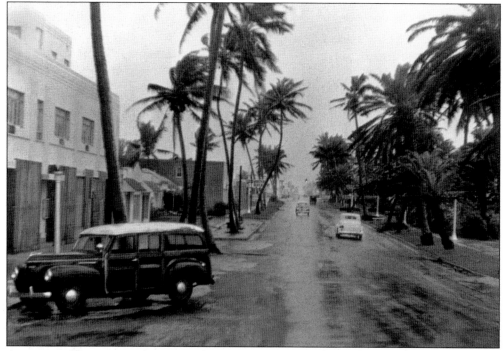

AFTER THE HURRICANE, ATLANTIC AVENUE, 1947. Considered the worst at that time, this hurricane destroyed many of the coconut and palm trees that lined Atlantic Avenue. The Ladies Improvement Association had been instrumental in the beautification and improvement of Atlantic Avenue. (Courtesy of Delray Beach Historical Society.)

BETTERMENT OF ROAD SIGN, 1950. Improvements included the widening of Atlantic Avenue and the construction of a new bridge while Fuller Warren was governor. (Courtesy of Delray Beach Historical Society.)

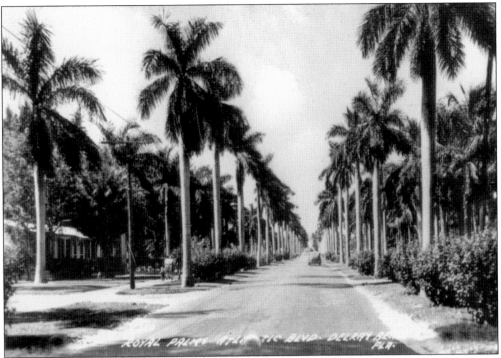

ATLANTIC AVENUE, LOOKING WEST, C. 1920. When Atlantic Avenue was lined with Royal Palms, many were damaged by a hurricane in 1947 or removed to widen the road when the new bridge was built. (Courtesy of Delray Beach Historical Society.)

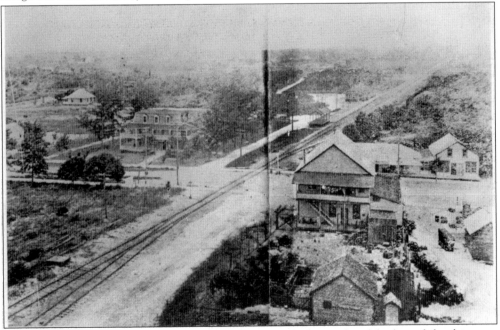

AERIAL VIEW OF ATLANTIC AVENUE, C. 1920. Henry Flagler's railroad facilitated the shipment of harvest to the North. Many of the vegetables and pineapples were sent via the Florida East Coast Railway. (Courtesy of Mim George.)

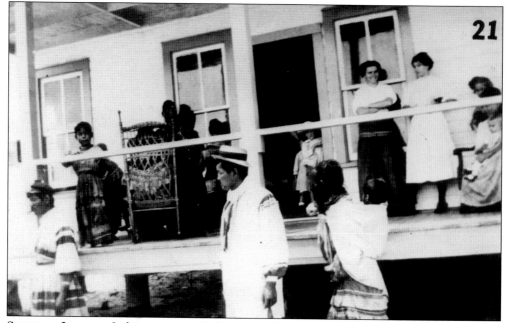

SEMINOLE INDIANS. Indians came to Delray to trade with Henry Sterling and Will Cathcart, bringing fresh venison and skins. Seminoles had skills and knowledge that were very helpful to the early pioneers. They often camped on the edge of town. (Courtesy of Delray Beach Historical Society.)

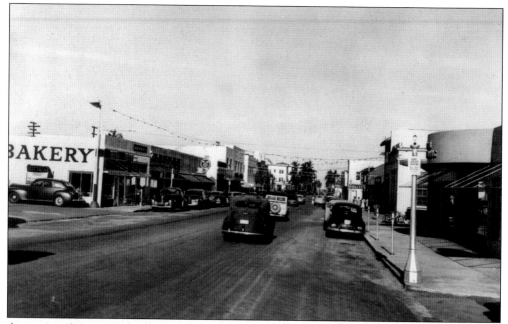

ATLANTIC AVENUE, C. 1950. Looking east from the FEC Railroad tracks shows McFee's Bakery on the north side of the street. On the south side was the bowling alley, the bank, and Lovetts Grocery Store. The Florida Power & Light Co. was on the corner of Atlantic Avenue and 4th Avenue. The population of Delray Beach was 6,312. (Courtesy of Delray Beach Historical Society.)

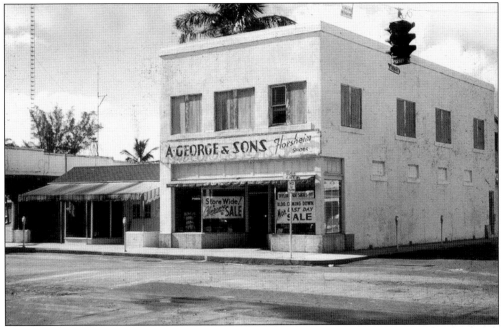

A. GEORGE & SONS, C. 1917. The A. George and Sons store was owned by Abraham George, who lived upstairs over the store on Atlantic and 4th Avenues, northwest side. The store sold Florsheim shoes and general merchandise. The original part of the store was the oldest general merchandise store in Florida, built in 1897. The mayor fined Abraham George $5 in 1911 for peddling without a license. (Courtesy of Mim George.)

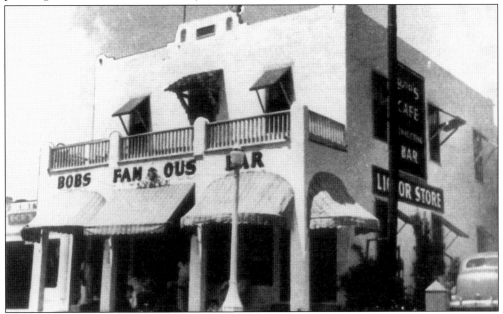

BOB'S FAMOUS BAR. This building may have been built as early as 1902–1903 by the McRae family as a store. It was stuccoed over and operated as Bob's from the 1930s to the 1950s, and it later became Powers Lounge. It was demolished in 2002. (Courtesy of Delray Beach Historical Society.)

ABRAHAM GEORGE BUILDING, c. 1911. The Abraham George building was located on East Atlantic and 4th Avenue, southeast side. (Courtesy of Mim George.)

Special to the Palm Beach Post
The Christmas parade passes the original A. George & Sons store (white building with flag) in 1920. The store opened 86 years ago.

Photos by BILL INGRAM/Staff Photographer
Today, Delray Beach's oldest family-run business occupies a corner on East Atlantic Avenue. It will close its doors by summer.

Georges watch inventory shrink, feel mixed emotions

GEORGE
From 1B

past empty shelves and browsed through half-full racks of slacks, still hoping to find suits for a wedding or a special occasion.

It's a different crowd moving into Delray Beach, the Georges said.

"They're younger and have different taste than what we carry," Alice George said.

As he stood behind the counter of his store, with his measuring tape in his breast pocket, Richard George described the custom service that set his family's

'We shorten or lengthen the sleeves, take the waistline in or let it out, carve the seat of the pants.'

RICHARD GEORGE

sleeves, take the waistline in or let it out, carve the seat of the pants," he said. "I'm a good fitter."

As a customer looked at himself in the mirror, Richard George looked to his sister-in-law and glanced around the store again.

STERLING COMMISSARY. This picture shows additions made since the building's construction in 1896. It is located on the south side of Atlantic and 1st Avenues. It was owned and operated by Mr. and Mrs. Henry J. Sterling, and later called the Rista Hotel. (Courtesy of Delray Beach Historical Society.)

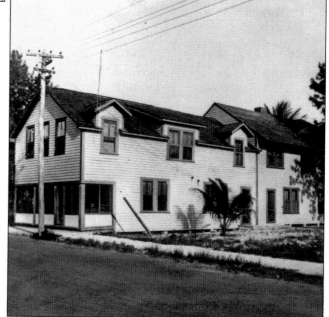

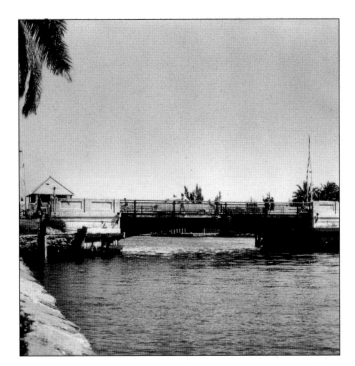

INTRACOASTAL, 1950S. The old 1926 bridge at Atlantic Avenue was replaced with a Chicago-style double leaf Bascule bridge in 1951–1952. (Courtesy of Delray Beach Historical Society.)

INTRACOASTAL BRIDGE, C. 1940. A view from Atlantic Avenue, looking west from the center of the Atlantic Avenue Bridge, shows a wood and concrete double-lift bridge built in 1926. The street is lined with coconut trees on the south side and date palms on the north. (Courtesy of Delray Beach Historical Society.)

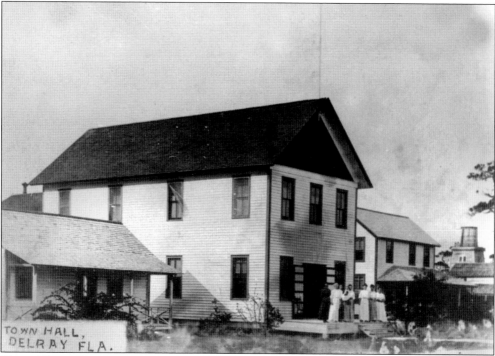

TOWN HALL, DELRAY, FLORIDA. The town hall is located on the 400 block of E. Atlantic Avenue, north side. It was built by "Ladies Improvement Association of Delray" and was originally a one-story building built in 1904. The two-story building was completed in 1906. This picture was taken prior to when Delray changed its name to Delray Beach. (Courtesy of Delray Beach Historical Society.)

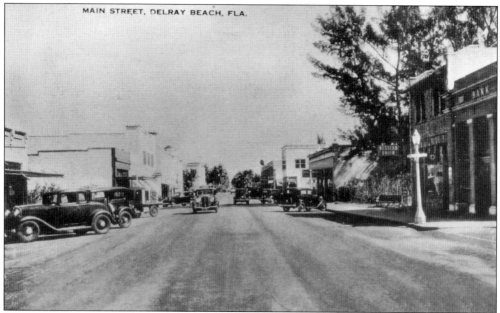

MAIN STREET, LATER ATLANTIC AVENUE, 1930. Atlantic Avenue was referred to as Main Street by the early settlers and pioneers. (Courtesy of Delray Beach Historical Society.)

**ATLANTIC AVENUE, NOW
SITE OF NEWSSTAND, C. 1953.**
Al Miller had his fishing tackle
store on the corner of Atlantic
and 5th Avenues. It is now
the location for the Delray
newsstand. (Courtesy of Marcia
and John Miller.)

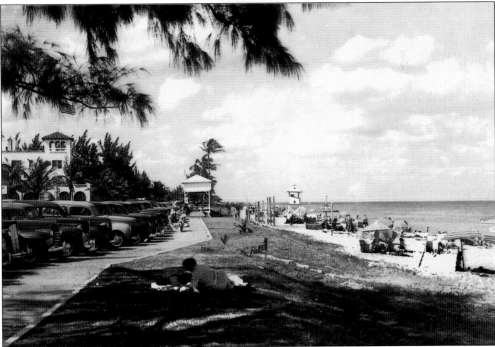

DELRAY BEACH, C. 1940s. At the corner of Atlantic and A1A, the Seacrest Hotel, on the left,
is now the Marriott Hotel. (Courtesy of Marcia and John Miller.)

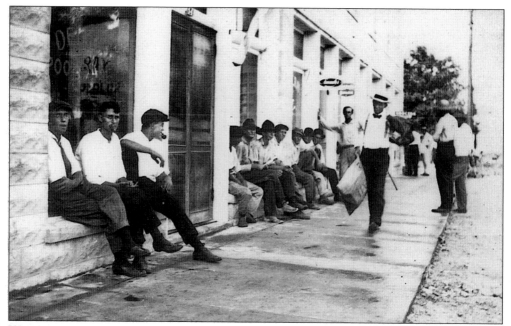

WAITING FOR THE POOL HOUSE TO OPEN, C. 1920. A lot of the men working for Henry Flagler's railroad left the Key West area since the conditions were difficult with the oppressive heat and mosquitoes. The men started walking north. Many stopped in Delray Beach.(Courtesy of Marcia and John Miller.)

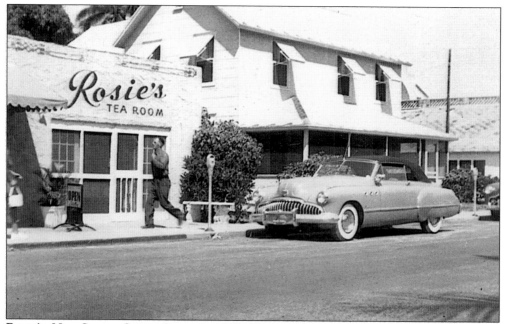

ROSIE'S, NOW SITE OF CATHY CROSS, C. 1953. This popular tea room on the corner of Atlantic and 5th Avenues continues the retail mode today. (Courtesy of Marcia and John Miller.)

DELRAY BEACH SCHOOL, c. 1928. Shown here are Norma and Bob Miller, the daughter and son of Al and Clara Wuepper Miller. (Courtesy of Marcia and John Miller.)

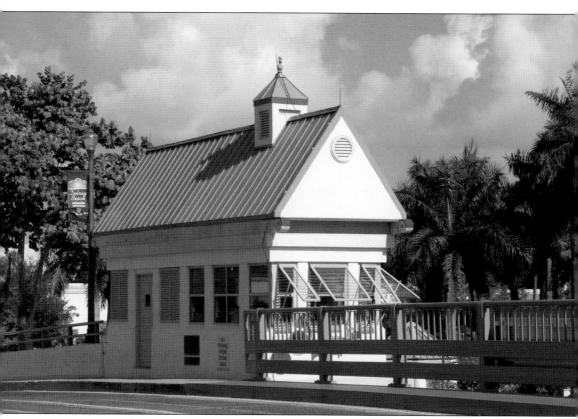

BRIDGE TENDER'S HOUSE. The rectangular masonry of the Bridge Tender's House was constructed upon completion of the bridge in 1952. Architect Robert Currie redesigned it to its present appearance in 1991. (Courtesy of Pat Healy-Golembe.)

Three

THE ARTISTS AND WRITERS COLONY

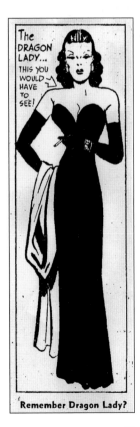

THE DRAGON LADY, C. 1940. Nedra Harrison attended high school in Delray Beach. She was the model for the character "Dragon Lady," created by the popular cartoonist Milt Caniss, who is known for "Terry and the Pirates." (Courtesy of Delray Beach Historical Society)

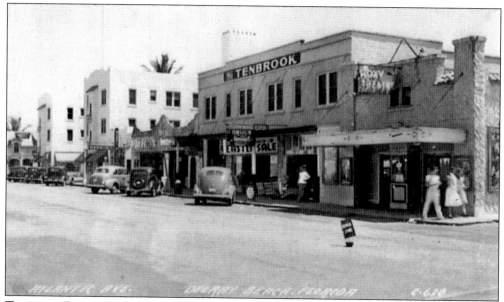

TENBROOK BUILDING, C. 1930S The Bijou on the right was stuccoed and renamed the Roxy. Silent movies were shown there. It was the only venue of its kind until the Delray Theatre opened with air conditioning and the Bijou closed due to competition. (Courtesy of Delray Beach Historical Society.)

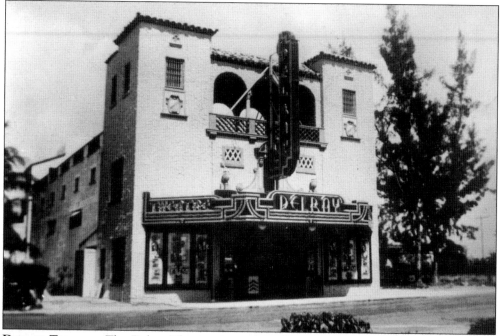

DELRAY THEATRE. The Delray Theatre opened on Christmas Day, 1923. Emmet Hall, the owner, had worked as an author of short stories and scenarios in Washington, D.C. The Japanese from Yamato, now part of Boca Raton, were real motion picture fans. Before the Catholic Church was built, their services were held in the theatre. (Courtesy of Delray Beach Historical Society.)

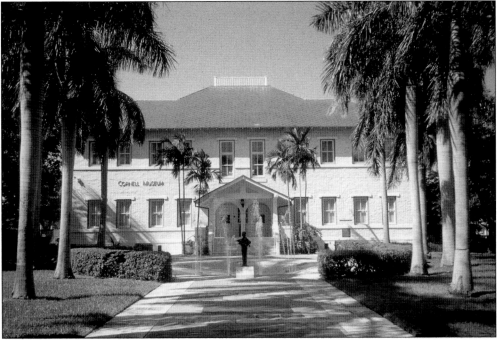

THE CORNELL MUSEUM OF ART HISTORY, C. 1913. Located in the restored Delray Elementary School building, the Cornell Museum of Art History is a part of the Old School Square Cultural Arts Center. The museum presents regional, national, and international exhibits, which rotate every eight weeks. The Delray Beach Historical Society Archives is on the second floor. (Courtesy of Old School Square Cultural Arts Center.)

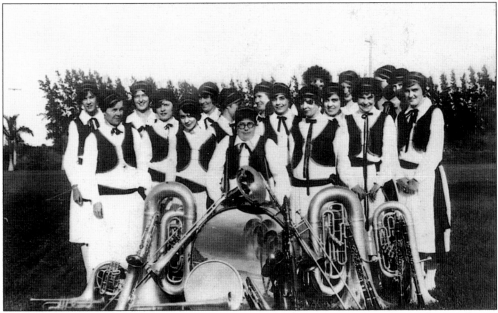

AL MILLER'S GIRLS BAND, C. 1913. The Band Shell now known as Veterans Park on Atlantic and 7th Avenues was the venue for concerts and performances. Al Miller had a barber shop and also a girls band. (Courtesy of Marcia and John Miller.)

LaFrance Hotel. Built in 1947 to accommodate African-American musicians and entertainers, this was the only hotel in Delray Beach that would receive black guests. This hotel was purchased by the Delray Beach CRA in 2003. (Courtesy of Glenn Weiss.)

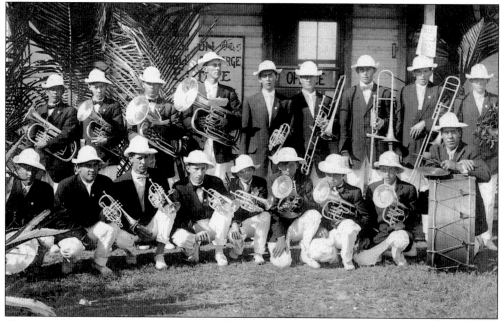

"Stars and Stripes Forever." This familiar tune was played by the Ocean City Band, during performances at Veterans Park, c. 1920. Al Miller was associated with band music, played the trumpet, and was very influential in the American Legion Post after he served in France in World War I. (Courtesy Marcia and John Miller.)

MUSIC TEACHER, JAMES LUKE SMITH. James Luke Smith is pictured here in 1915. He played in a local band in Delray Beach and lived on 5th Avenue, earlier known as "The Sands" area of Delray Beach. The blacks lived on the west side of Swinton Avenue and were provided a "pass" to come to the east side of Swinton Avenue. (Courtesy of Thomas Kemp.)

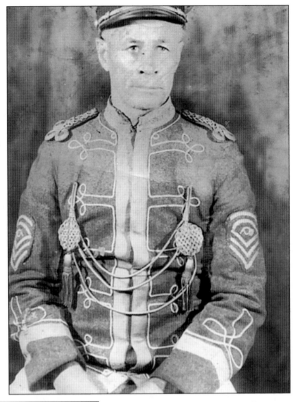

OPERA SINGER ORA SMITH WAKE. This talented singer performed at Boston Conservatory for Music and lived on 5th Avenue in the area known as the Sands. She sang with the well-known Wings Over Jordan, a traveling singing group. She also taught music and voice at her home. This picture was taken c. 1920. (Courtesy of Thomas Kemp.)

47

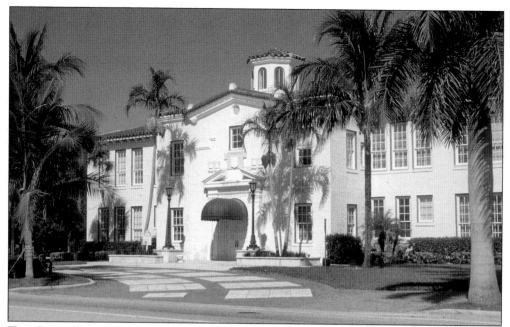

THE CREST THEATRE, C. 1925. As part of the Old School Square Cultural Arts Center, the Crest presents a variety of theater music and dance performances as well as Broadway cabaret. The building also houses restored classrooms, now used for art classes, workshops, meetings, and receptions. (Courtesy of Old School Square Cultural Arts Center.)

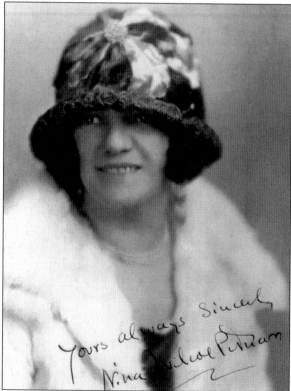

NINA WILCOX PUTNAM. Delray Beach was known as the "Artists and Writer's Colony," attracting many people in the arts. Nina Putnam was a "Jazz Age" writer for *The Saturday Evening Post* and other magazines. She eventually purchased a house on the Intracoastal in Delray Beach. (Courtesy of Delray Beach Historical Society.)

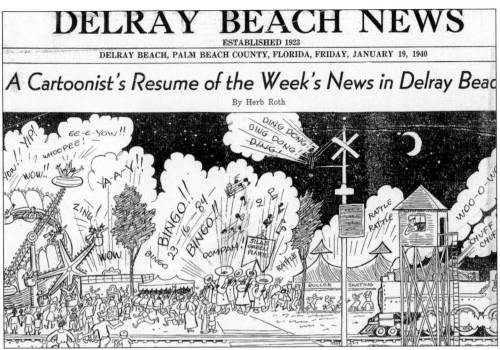

A Cartoonist's Resume of the Week's News in Delray Beac[h]

By Herb Roth

CARTOONIST HERB ROTH, C. 1934. Roth spent many seasons in Delray Beach, also known as the "artists and writers colony." His cartoons were often featured in the *Delray Beach News*. Pictured here is one of his cartoons in the *Delray Beach News* of January 19, 1940. (Courtesy of Delray Beach Historical Society.)

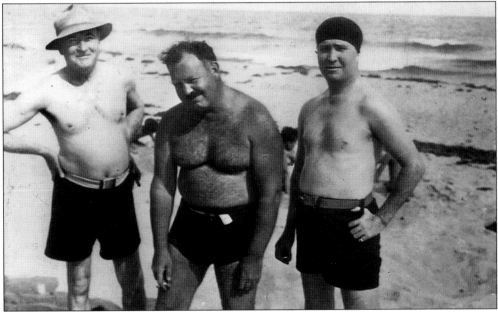

ARTISTS AND WRITERS COLONY. Delray Beach attracted many nationally known writers and cartoonists. From left to right are W.J. Pat Enright (political cartoonist for the *Miami Herald* and *Palm Beach Post*), Herb Roth (known for his local editorial cartoons for the *Delray News*), and Joe Williams (sports columnist). (Courtesy of Delray Beach Historical Society.)

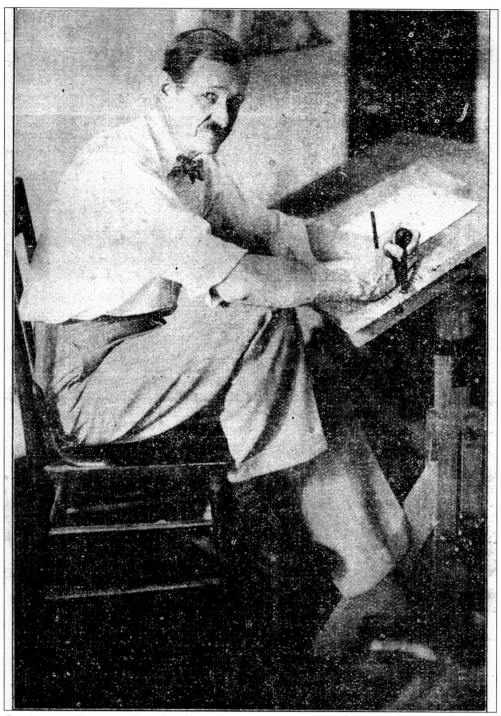

CARTOONIST FONTAINE FOX. Fox began his visits to Delray Beach in the 1920s and had an office above the Tap Room, now the location of Peter's Stone Crabs restaurant. Fox was nationally famous for his syndicated comic strip "Toonerville Trolley." (Courtesy of Delray Beach Historical Society.)

VILLA ABRIGO, "BANKERS ROW." Matt Gracey invited many of the artists and writers to his home at Villa Abrigo. Jim Raymond, who drew the characters for "Blondie," and his wife Bootie, an actress who performed for the Delray Beach Playhouse, lived and entertained their counterparts in this villa. (Courtesy of Vicente Martinez.)

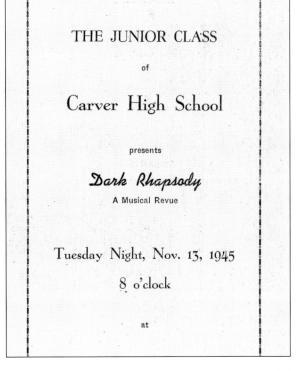

THE JUNIOR CLASS

of

Carver High School

presents

Dark Rhapsody
A Musical Revue

Tuesday Night, Nov. 13, 1945

8 o'clock

at

MUSIC PRESENTATIONS OF THE CARVER HIGH SCHOOL, 1945. Performances by African Americans and for African Americans were held at the Delray Colored Theatre. (Courtesy of H. Ruth Pompey.)

P.O. Box 787 of Edna St. Vincent Millay. One of many authors who spent time in Delray was Edna St. Vincent Millay. During a recent exhibition of the Delray Beach Historical Society featuring Millay's post office box, the question was asked "Do you know where Edna Millay and Eugen Boissevain lived in Delray Beach?" (Courtesy of Delray Beach Historical Society.)

The Junior and Citizenship Departments

of the

Delray Beach Woman's Club

Present

The Frolics of 1950

Staged and Directed by:

Mrs. James J. Martin

Mrs. Robert Slager

Mrs. Charlotte M. Grant

Mrs. Mary Lee Hancock

Cover Design by Mrs. Stratton Snow

Advertising Chairman Mrs. William F. Hertz

Cavalcade of Swim Suits
by Courtesy of
Zuckerman's

April 28th and 29th School Auditorium 8:15 P. M.

The Frolics of 1950. The Delray Beach Women's Club was an active group that brought entertainment to Delray Beach. (Courtesy of Mim George.)

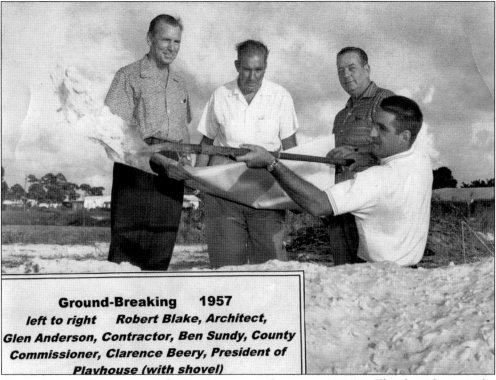

Ground-Breaking 1957
left to right Robert Blake, Architect,
Glen Anderson, Contractor, Ben Sundy, County
Commissioner, Clarence Beery, President of
Playhouse (with shovel)

DELRAY BEACH PLAYHOUSE, GROUNDBREAKING CEREMONY, 1957. The first show at the Delray Beach Playhouse was "The Philadelphia Story" in January 1958, followed by "Three Men On A Horse." There was neither heat nor air-conditioning in the theatre. (Courtesy of Delray Beach Playhouse.)

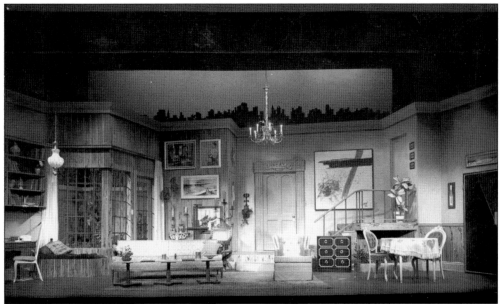

ST. PAUL'S PARISH HALL, 1949. The Little Theatre of Delray Beach was held in the Parish Hall prior to the opening of the Delray Beach Playhouse. (Courtesy of Delray Beach Playhouse.)

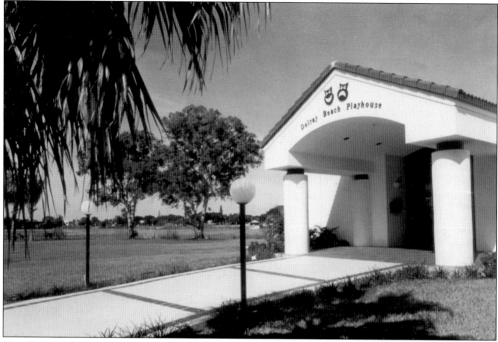

THE DELRAY BEACH PLAYHOUSE. Now celebrating its 57th year of life performances, the Delray Beach Playhouse is considered "the community theatre." (Courtesy of Delray Beach Playhouse.)

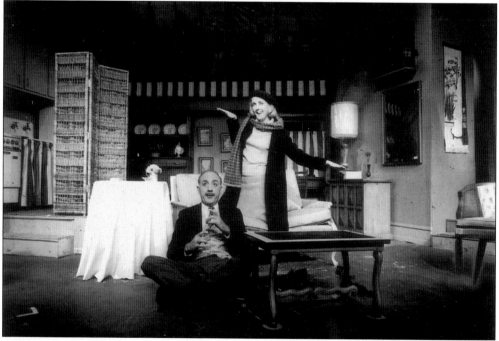

BAREFOOT IN THE PARK. This play was shown in April 1967 at the Delray Beach Playhouse. Ernest "Ernie" Simon and Kathy Lord appeared in the Neil Simon play. Mr. Simon practices law in Delray Beach today and is on the board of directors of the Delray Beach Playhouse. (Courtesy of Ernest "Ernie" Simon, Esq.)

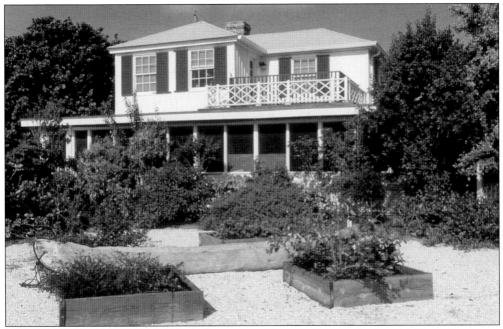

THE SANDOWAY HOUSE, HOME OF THE SANDOWAY NATURE CENTER. Built in 1936, the Sandoway House was designed in resort Colonial Revival style. It is listed in the National Register of Historic Places. (Courtesy of Pat Healy-Golembe.)

THE MILAGRO CENTER. Home of a multifaceted arts program and the STARS program, the Milagro Center features a cultural experience and expression component for children. The building is located at 101 S.E. 2nd Avenue. (Courtesy of Dharma Foundation.)

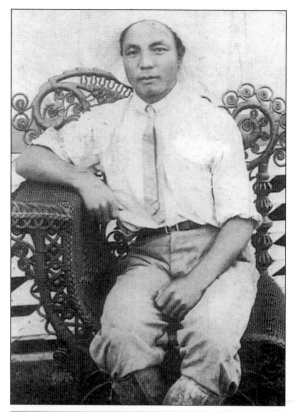

"GEORGE" SUKEJI MORIKAMI. An arrangement was made with Henry Flagler of the Florida East Coast Railroad to bring Japanese farmers from Miyazu, Japan, to Delray to learn modern farming methods. Mr. Morikami arrived in Delray at the age of 19 to seek his fortune. He became a successful produce broker. The Morikami Museum and Japanese Gardens was his gift to South Florida. (Courtesy of Virginia Snyder.)

MAYO GALLERIES OPENING, 1953. Nathan Saltonstall, well-known Boston collector and founder of Boston's Institute of Contemporary Art, was one of the sponsors for this venture featuring modern art. Pictured here from left to right are Mr. and Mrs. Herrick Hammond, Mrs. William Morris, and Mrs. Dorothy Heist, sister of the well-known painter, Peter Heist. (Courtesy of Delray Beach Historical Society.)

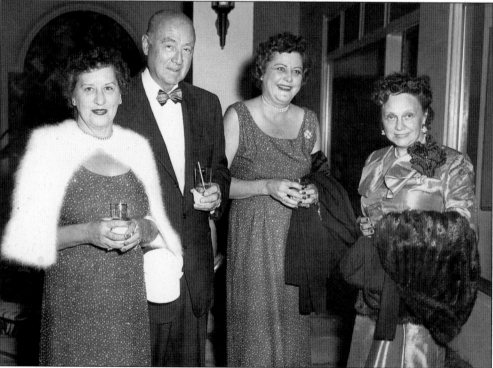

W.J. "PAT" ENRIGHT, CARTOONIST. Enright achieved fame as a cartoonist for the Democratic party. He moved to Delray Beach in 1934 and became a daily editorial cartoonist for the *Miami Herald*. He also drew for the *Palm Beach Post*. He lived on N.W. 12th Street near Lake Ida. (Courtesy of Delray Beach Historical Society.)

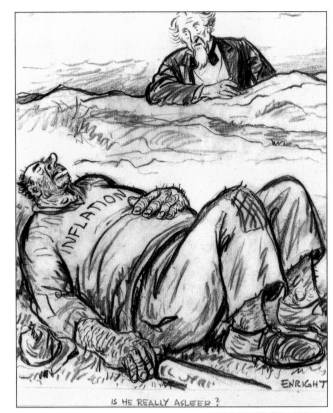

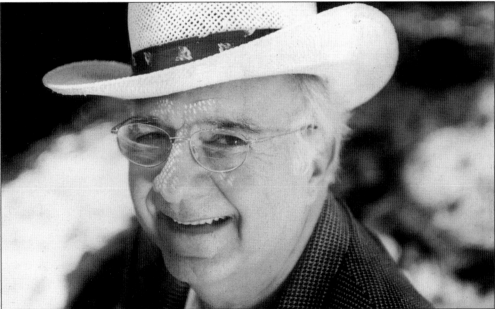

ALEXANDER "SANDY" SIMON, AUTHOR OF *REMEMBERING*. Sandy's family arrived in Delray Beach in 1912. His father was a produce broker. His book, *Remembering*, a historical book about South Palm Beach County, has become a favorite in the homes in Delray Beach. Sandy continues as a writer and is working on his third book. (Courtesy of Sandy Simon.)

VERA ROLLE FARRINGTON. Farrington is the founder of Expanding and Preserving Our Cultural Heritage, Inc. (EPOCH), which is located in the S.D. Spady Cultural Arts Museum. EPOCH researches and documents the cultural history of Delray Beach and Palm Beach County, especially as it relates to African Americans. (Courtesy of S.D. Spady Museum.)

VIRGINIA SNYDER, A LIVING LEGEND OF DELRAY BEACH. Virginia, writer-poet, and her husband Ross reside in the Cathcart House, the oldest home in Delray Beach. The stories of the famed *Murder She Wrote* were inspired by her work as a private investigator. She has been interviewed on *Late Night with David Letterman*, NBC's *Today*, *20/20*, *Unsolved Mysteries*, and many other national and international television shows. (Courtesy of Virginia Snyder.)

BAD BOYS II, WILL SMITH AND MARTIN LAWRENCE. This house, known as the Coca-Cola Mansion, was the scene of the actual demolition shown in a motion picture that was filmed in Delray Beach in 2002. The location was 1105 S. Ocean Boulevard. (Courtesy of Delray Beach Historical Society.)

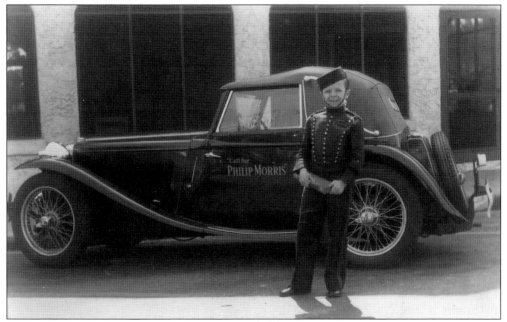

JOHNNY, THE ACTOR. This actor was known for the Philip Morris advertisement. He lived in Delray Beach. (Courtesy of Delray Beach Historical Society.)

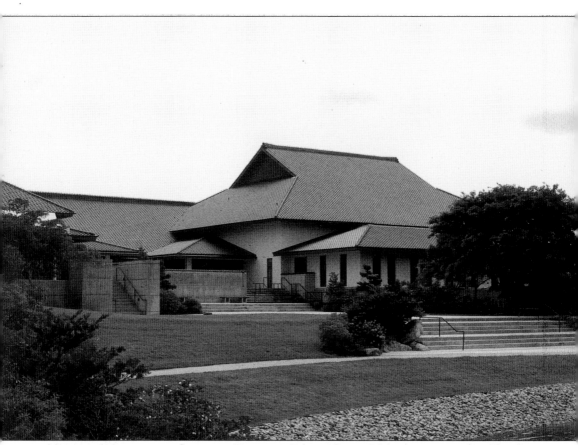

MORIKAMI MUSEUM AND JAPANESE GARDENS. Sukeji "George" Morikami arrived in Florida in 1906 and made his fortune brokering pineapples. However, he lost his fortune during the Great Depression. After that, he made money buying and selling parcels of land. This lush, green oasis of Japanese culture was his gift to South Florida. More than 100,000 tourists and residents visit the "living museum". (Courtesy of Vicente Martinez.)

Four

BUILDINGS

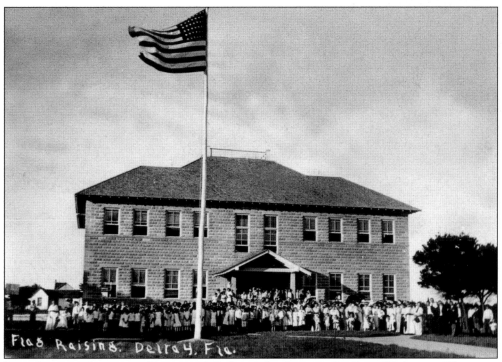

FLAG RAISING, CHRISTMAS DAY, 1915. Delray School is now the Cornell Museum. There was a one-room schoolhouse on this location originally. This picture was taken prior to the merger of Delray and Delray Beach. (Courtesy of Delray Beach Historical Society.)

THE INN—DELRAY'S FIRST HOTEL. Built in 1902 by Frank W. Chapman, this hotel was located beside the railroad tracks where the Sun Trust building is located today. This view is from Atlantic Avenue and S.W. 3rd Avenue. The hotel was destroyed by fire in 1925. (Courtesy of Delray Beach Historical Society.)

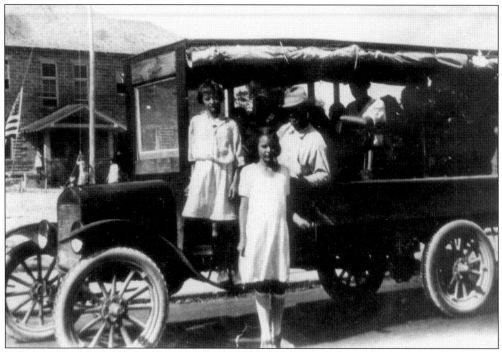

SCHOOL BUS IN FRONT OF DELRAY HIGH SCHOOL, C. 1914. Ozzie Priest, driver, is pictured in front of Delray School, which is now the Cornell Museum and home of the Delray Beach Historical Archives. (Courtesy of Delray Beach Historical Society.)

FIRST BAPTIST CHURCH, c. 1918. This building has been converted into a drug substance program facility. Osceola Church is located at S.E. 4th Avenue and 3rd Street. (Courtesy of Delray Beach Historical Society.)

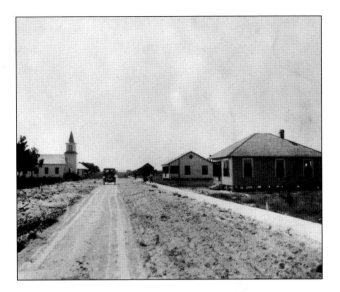

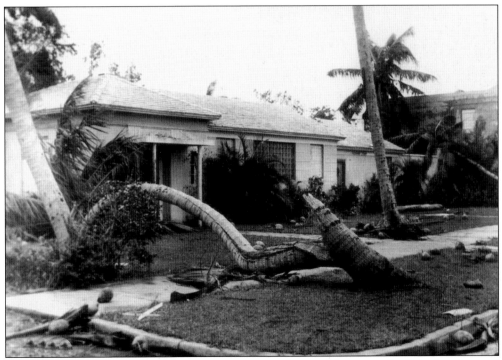

PATIO DELRAY RESTAURANT. Many properties were devastated as a result of the hurricane of 1947. (Courtesy of Delray Beach Historical Society.)

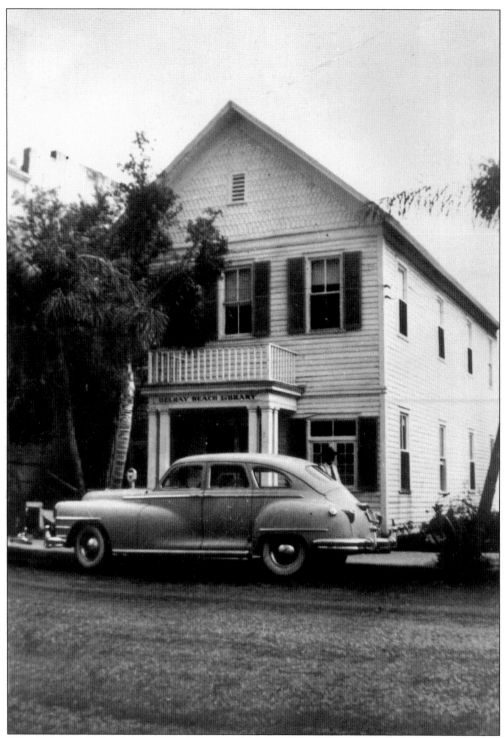

Women's Club Building. In 1906 this building was completed. The Delray Beach Library was located on the second floor. This building was also known as the "Ladies Improvement Association" building. (Courtesy of Delray Beach Historical Society.)

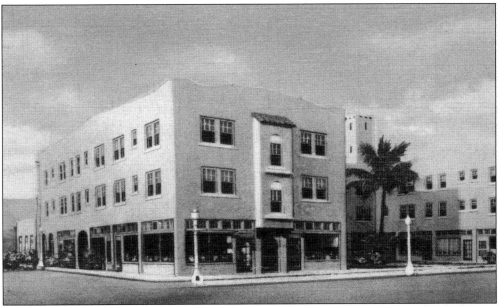

BON AIRE HOTEL. The Bon Aire Hotel was built in 1925 by Henry Sterling with a retractable roof garden restaurant. Located where Worthing Park is now, it was demolished in the 1970s. (Courtesy of Delray Beach Historical Society.)

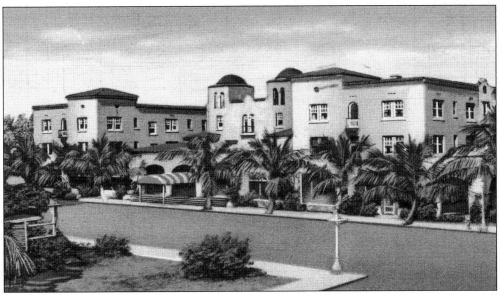

COLONY HOTEL, C. 1935. After it was purchased by the Boughton family, the Alterep Hotel's name was changed to the Colony Hotel. It is now owned by the family's daughter, Jestena Boughton. (Courtesy of Delray Beach Historical Society.)

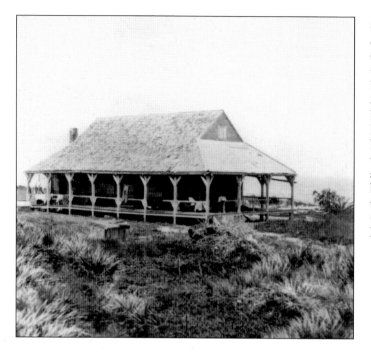

ORANGE GROVE HOUSE OF REFUGE. The Orange Grove House of Refuge was built in 1876 by the United States Life Saving Services. It is the first-known building in Delray Beach. It was often used by the "barefoot mailman" who carried the mail up and down South Florida beaches. Sour orange trees surrounded the site. (Courtesy of Delray Beach Historical Society.)

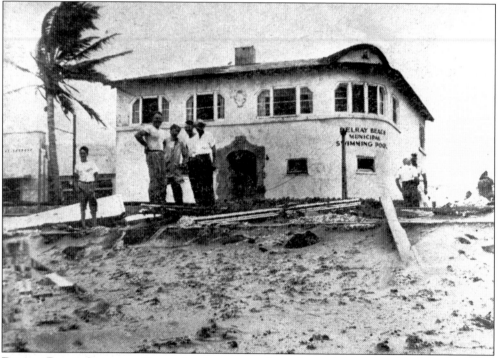

DELRAY BEACH SWIMMING POOL. A salt water pool was located on west side of this building, which was at the corner of Atlantic Avenue and A1A. Works Progress Administration (WPA) built this pool during the Great Depression of the 1930s. This photo was taken after the 1947 hurricane. (Courtesy of Delray Beach Historical Society.)

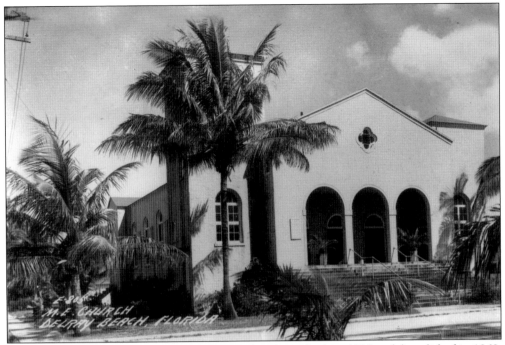

CASON MEMORIAL METHODIST CHURCH. This church was built in 1928 and demolished in 1969. It was located at 85 N.E. 6th Avenue. (Courtesy of Delray Beach Historical Society.)

SEACREST HOTEL, AFTER THE HURRICANE OF 1947. A Marriott Hotel is now on the same site. The Seacrest was demolished in the early 1980s. (Courtesy of Delray Beach Historical Society.)

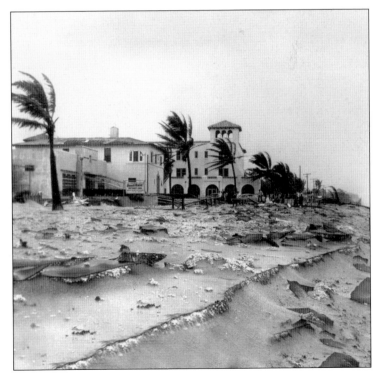

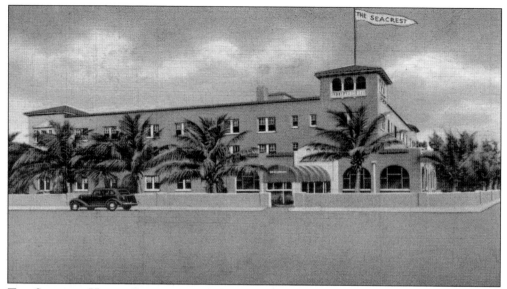

THE SEACREST HOTEL, LOCATED ON A1A AND ATLANTIC AVENUE. The Seacrest Hotel was located on A1A and Atlantic Avenue. This is now the location of the Marriott Hotel. (Courtesy of Delray Beach Historical Society.)

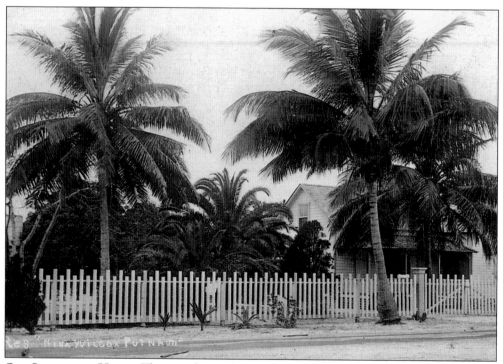

OLD SCHABINGER HOUSE. This was the residence of Nina Wilcox Putnam, novelist and short-story writer, and was later purchased by Mrs. Weir. It was sold sometime between 1963 and 1965, and Trinity Lutheran Church and School moved to this property in July 1965. (Courtesy of Marcia and John Miller.)

GEARHART DAY SCHOOL. Mim George, who resides in Delray Beach today, taught kindergarten at this private school. The school was originally located where Banker's Row is today. (Courtesy of Mim George.)

THE GREATER DELRAY BEACH CHAMBER OF COMMERCE. Established in 1925, the chamber of commerce leased office space in 1951 (as pictured here). The chamber serves as a major resource for businesses in Delray Beach today. (Courtesy of The Greater Delray Beach Chamber of Commerce.)

THE PRICE HOUSE, C. 1935. The Monterey style of the Price House is significant as it is an example of the work of prominent local architect Samuel Ogren Sr. His work included the Delray Beach High School and the Arcade Tap Room. The Historic Preservation Board designated the house as a local landmark. (Courtesy of Tamelyn "Tammy" Sickle.)

THE PRICE HOUSE TODAY. Officially known as the Price House, this house was moved from the beach to another location in Delray Beach. Tamelyn "Tammy" Sickle, who lives in Delray Beach, purchased it from the Voss family. (Courtesy of Tamelyn "Tammy" Sickle.)

HOLIDAY HOUSE FOR TWO. This house is typical of resort homes advertised for seasonal rentals. Shown in *The American Home*, February 1938, snowbirds from the North were targeted for marketing. (Courtesy of Delray Beach Historical Society.)

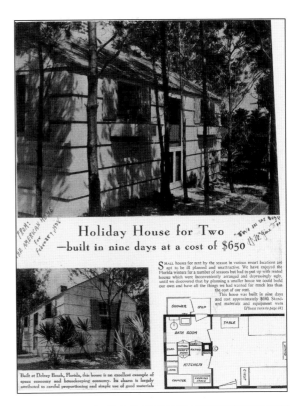

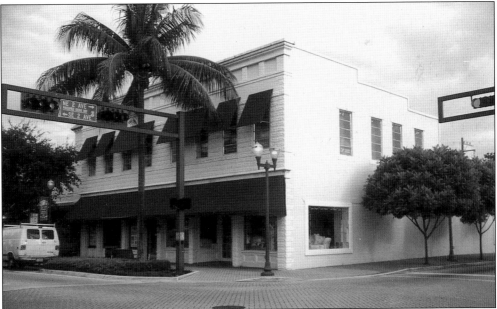

BUTLER BUILDING, FORMERLY KNOWN AS THE CATHCART BUILDING. William James Cathcart constructed this building in 1912. When Mr. Cathcart closed his store, Abraham George purchased it. It was later sold it to Carlisle Butler who operated Butler's Hardware. It is located on Atlantic and N.E. 2nd Avenues, and Sal's Sporting Goods recently occupied the building. It now houses a gallery and retail shops. (Courtesy of Vicente Martinez.)

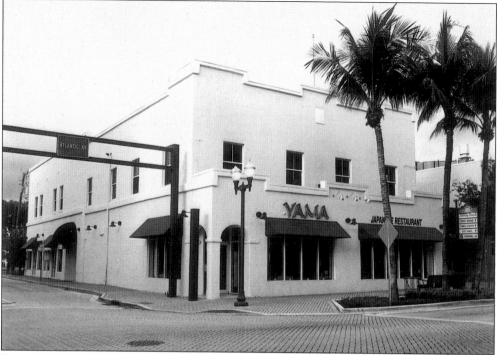

YAMA SUSHI RESTAURANT. This building is the former location of the post office, and from the 1920s to 1940s, it was the Masonic Building. (Courtesy of Vicente Martinez.)

REEVE BRIGHT OFFICE BUILDING. Formerly the Reeve Bright Office building, this is now a multi-use building at 1st and Atlantic Avenues. It now houses Sopra Restaurant and business offices. (Courtesy of Vicente Martinez.)

The Former Tap Room. This is the present location of Peter's Stone Crab Restaurant. (Courtesy of Pat Healy-Golembe.)

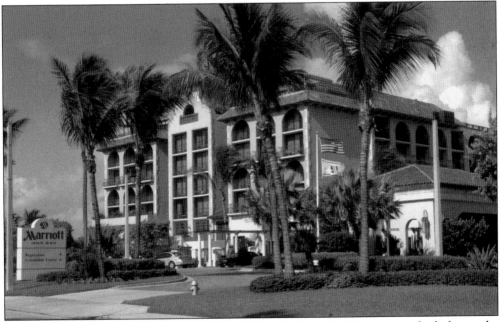

Marriott Hotel. Formerly the Camino Real Holiday Inn, the Marriott was built facing the ocean on the site of the 1923 Seacrest Hotel, which was demolished in the early 1980s. (Courtesy of Pat Healy-Golembe.)

MATT. GRACEY
INSURANCE - REAL ESTATE
DELRAY BEACH, FLA.

Feb. 25, 1935

Received of Miss Anne Douglas, c/o Otto Hack,
Fred F. French Building, New York City, $150.00
for the seasonal rental on the Abraham George
south apartment on South Federal Highway.

The apartment to be furnished for housekeeping
as shown with the additions of the bed linens
and blankets.

Miss Douglas is to put up her deposit for the
lights and to pay for the water consumed, and
is also to pay Mr. George for the water at the
rate of $1.50 per month, the first month of
which is hereby acknowledged.

The apartment not to be sublet.

_____ AGENT

_____ ACCEPTED

MATT GRACEY. This letter from Matt Gracey is an acknowledgement of deposit on behalf of Abraham George, owner of a seasonal rental. The water bill was $1.50 per month. Matt Gracey was instrumental in helping to locate seasonal rentals. This same property located on South Federal Highway was used as a shelter for the Simon family during a major hurricane. (Courtesy of Delray Beach Historical Society.)

Five

CULTURAL LOOP

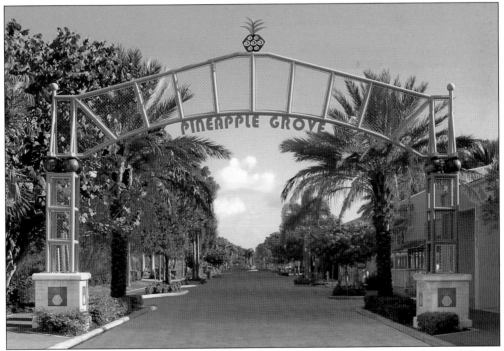

PINEAPPLE GROVE ENTRANCE ARCH. Architect Robert Currie and Associates created this as part of the Pineapple Grove Main Street plan in order to enhance Pineapple Grove's identity and define an entryway. The tiles at the bottom of supporting pillars contain donors' names. (Courtesy of Pat Healy-Golembe.)

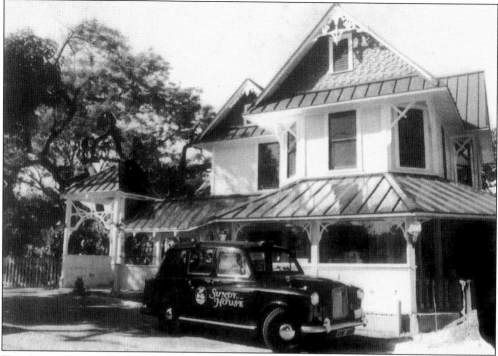

THE SUNDY HOUSE. Built in 1902 by J.A. Leatherman, the Sundy House was occupied by John Shaw Sundy, who became Delray's first mayor. It typifies the early Revival style featuring a wide veranda, reminiscent of Eastern Stick style. (Courtesy of Virginia Snyder.)

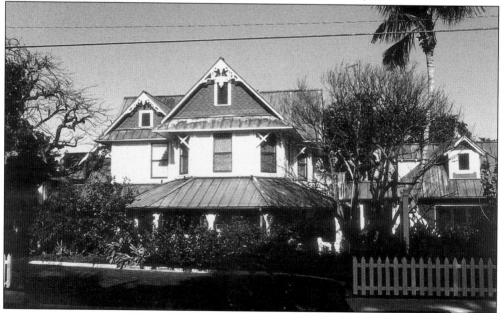

PHOTO OF THE SUNDY HOUSE OF TODAY. The Sundy House is now a restaurant and inn. The grounds have been transformed into tropical jungle oasis, now called the Taru Gardens, in the heart of Delray Beach. It was placed on the National Register of Historic Places in 1992. (Courtesy of Dharma Holdings, Ltd.)

THE CATHCART HOUSE. Dr. J.A. Leatherman built this wood-frame vernacular in the Bahamian style in 1902. It was sold to businessman W.J. Cathcart in 1910. The house is three months younger than the Sundy House and built with wood from the Bahamas. (Courtesy of Virginia Snyder.)

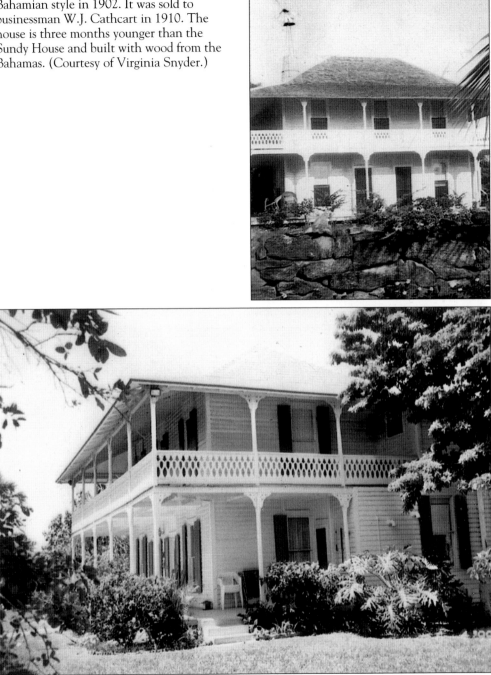

THE CATHCART HOUSE TODAY. This house was purchased on December 8, 1910, by W.J. Cathcart for his wife, Grace Florence Cathcart. It is located on Swinton Avenue, south of Atlantic Avenue, and is presently the home of Ross and Virginia Snyder. It is the oldest house in Delray. (Courtesy of Virginia Snyder.)

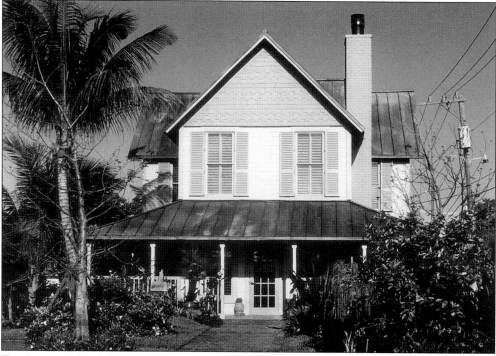

THE RECTORY. Built by J.A. Leatherman in 1903 in the vernacular style, the rectory was located at 14 S. Swinton Avenue. It was the parsonage for the First Methodist Church, built on the same lot in 1903. The church was destroyed in 1928 by a hurricane but the parsonage survived. Henry Sterling donated the land for the two buildings. (Courtesy of Dharma Holding, Ltd.)

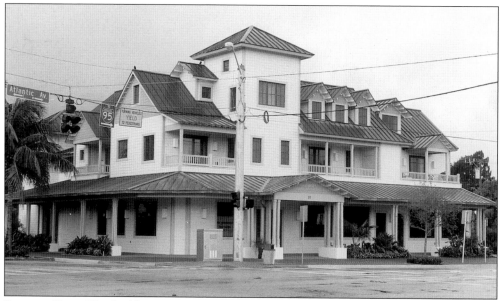

RECTORY PARK. This building was constructed as a larger replica of the Rectory Building, erected in 1903. It is a mixed-use building of retail stores on the ground floor and residential above. It was built in the Caribbean style in 2001. (Courtesy of Dharma Foundation, Ltd.)

First Methodist Church and Parsonage, Built c. 1903. The church and parsonage were built on the corner of Atlantic Avenue and S. Swinton. It is now the location of Rectory Park. (Courtesy of Delray Beach Historical Society.)

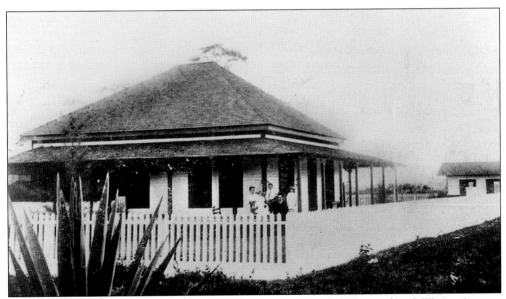

Home of Dr. J.R. Cason Jr. Family, built c. 1907. Formerly located at S.W. 1st Avenue at W. Atlantic Avenue, this house was moved to the Lake Ida area, which was named for Ida Linton, wife of Congressman Linton. Dr. Cason came to Delray Beach in 1905 and practiced medicine until his death in 1936. On the porch, from left to right, are Mrs. J.R. Cason Jr. (holding Mary Katherine), Roy, Dr. J.R. Cason Jr., and Joanna. (Courtesy of Mary Lou and Sandy Jamison.)

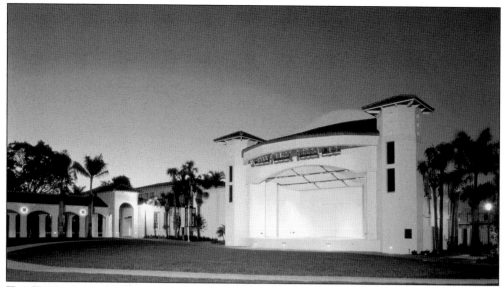

THE ENTERTAINMENT PAVILION, OLD SCHOOL SQUARE. This is phase one of a master plan for expansion at Old School Square Cultural Arts Center. The facility presents concerts and films and hosts a variety of community festivals and events. It is also used as a facility for corporate and private events. It was completed in February 2002. (Courtesy of Old School Square Cultural Arts Center.)

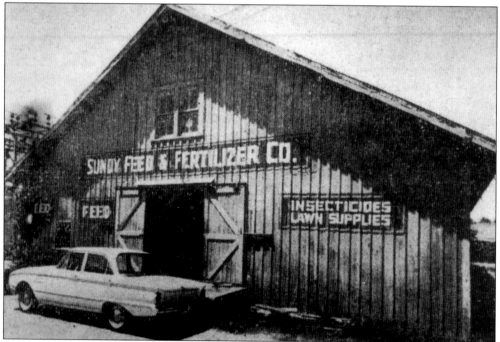

SUNDY FEED STORE. Established in 1914, Sundy Feed Store served as the main supplier for the agriculture industry for many years at 36 N. Railroad Way. The building was moved to the Morikami Museum in the early 1990s and later moved to "Yesteryear Village" at the fairgrounds in West Palm Beach. It is now the site of the restored FEC Railroad Station. (Courtesy of Delray Beach Historical Society.)

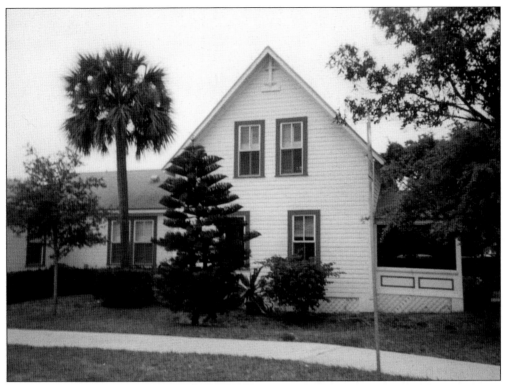

THE CLARK HOUSE, RESIDENCE OF ONE OF THE ORIGINAL FARMING FAMILIES. This residence was built in 1896 in the frame vernacular style. Coach Clark, who coached at Atlantic High School, lived in this house. It is now the law office building for Weiner, Aronson, and Mankoff. (Courtesy of Michael S. Weiner, Esq.)

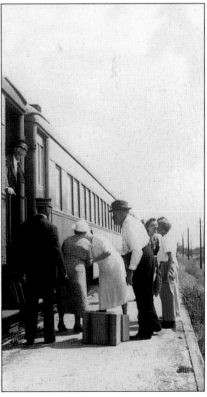

FLORIDA EAST COAST RAILROAD DURING THE EARLY 1940s. The railroad facilitated travel to other parts of the country. Pictured on the far right is John Miller, who continues to live in Delray Beach today. On the far left is Margaret Wuepper, who helped to organize the Trinity Lutheran Church. (Courtesy of Marcia and John Miller.)

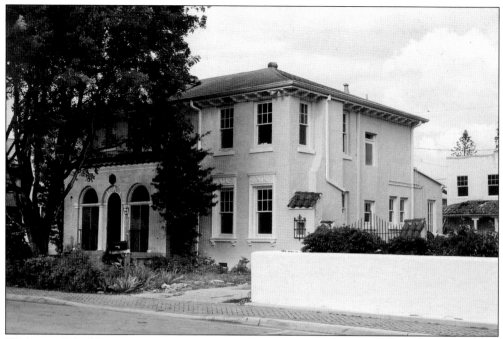

"Bankers Row" Dwellings, 1920s to 1930s. Located at N.E. 1st Avenue between 2nd and 3rd Streets, this block contains a series of architectural styles. It was once the home of many prominent business owners in Delray Beach. (Courtesy of Vicente Martinez.)

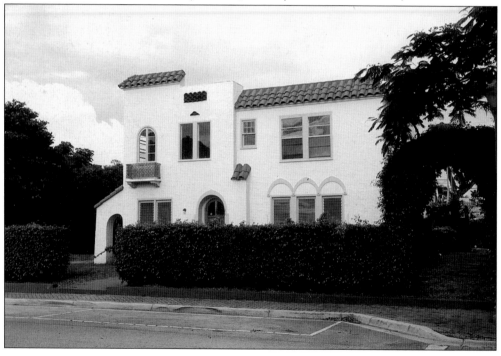

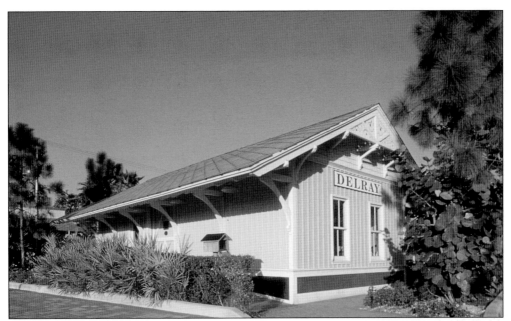

THE DEPOT OF THE FLORIDA EAST COAST RAILWAY STATION, C. 1896. The original site of the depot was southeast of the tracks. After the end of passenger service, the old passenger station was moved west of town. In 1995–1996, the Delray Beach Historical Society moved the station back to its original location and restored it. This is the surviving section. (Courtesy of Pat Healy-Golembe.)

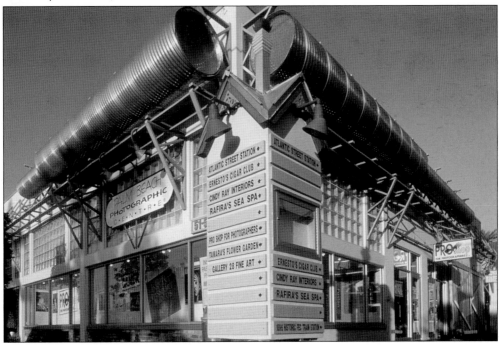

PALM BEACH PHOTOGRAPHIC. Housed in a development within the Ocean City Lumber Company courtyard, Palm Beach Photographic is another result of the revitalization that has taken place in the Pineapple Grove district of Delray Beach. (Courtesy of Pat Healy-Golembe.)

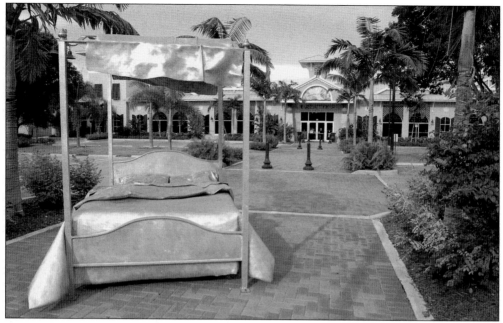

ARTWALK IN PINEAPPLE GROVE. As one walks along N.E. 2nd Avenue, the creativity of a local artist is given a venue for display in front of Creations, a mini-design center. This bed sculpture is part of the Artwalk, a 1.3-mile walking trail that links the cultural history and contemporary life of Delray Beach. (Courtesy Pat Healy-Golembe.)

THE GREEN MARKET. On Saturdays, from October to April, local produce and small gift items are sold in the area known as Worthing Park. Robert "Bob" Worthing was city clerk in Delray Beach in the 1950s and 1960s. His widow is 90 years old and still lives in Delray Beach. (Courtesy of Gonzalee Ford.)

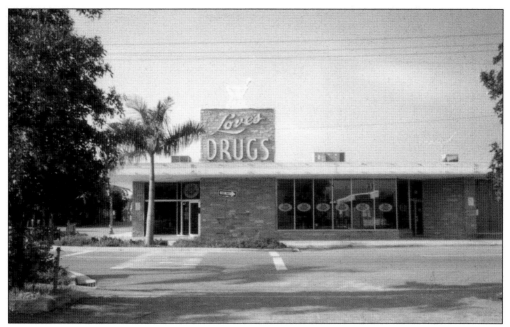

LOVE'S DRUGS. This sign has been preserved as a memento of the past when the Love family operated drugstores in Delray for most of the 20th century. There is no longer a drug store in the building. James L. Love Sr. was Reverend Cason's son-in-law. He came to Delray as the first registered pharmacist and opened Love's Drugs in 1912. (Courtesy of McCall Credle-Rosenthal.)

CASON COTTAGE MUSEUM. Built c. 1915 as a retirement home for Rev. and Mrs. John R. Cason, this structure is a good example of Delray Beach's many cottages. Descendants of the Casons still live in Delray Beach. The house is now operated by the Delray Beach Historical Society as a museum reflecting Florida family lifestyles between 1915 and 1935. (Courtesy of Pat Healy-Golembe.)

THE COURTYARD, OCEAN CITY LUMBER. Situated in the Pineapple Grove section of Delray Beach, this area is known for its popular restaurants and the Palm Beach Photographic Center. At one time Delray Beach used the motto "The Ocean City." Janet and Tom Onnen assembled this parcel of land in 1995. (Courtesy of Meisner Electric Company.)

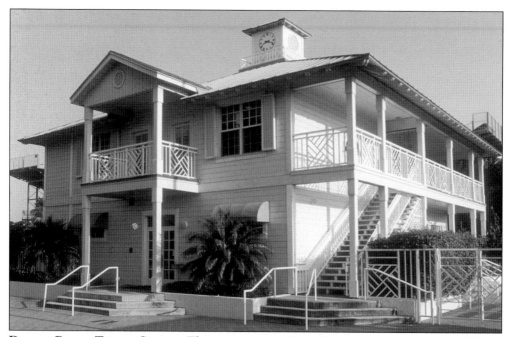

DELRAY BEACH TENNIS CENTER. The tennis center hosted the Lipton International Players Championships in 1985 and the World Championship of Tennis in 1982 and 1983. It has been a premier destination for tennis. Chris Everett and Serena and Venus Williams have played in tournaments in Delray Beach. The new tennis center held its first tournament, the Virginia Slims tournament, in 1994. (Courtesy of Pat Healy-Golembe.)

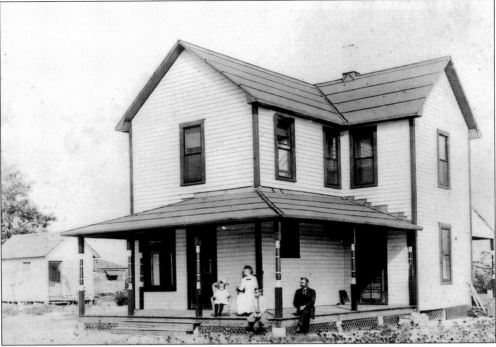

CASEBOLT RESIDENCE, BUILT C. 1907. The Sparks family is pictured here in 1912. They owned a pineapple farm. The house was enlarged and the shape of the house was changed. Irene Moore, a well-known milliner who had a hat shop on Atlantic Avenue, owned it for many years. (Courtesy of Tamelyn "Tammy" Sickle.)

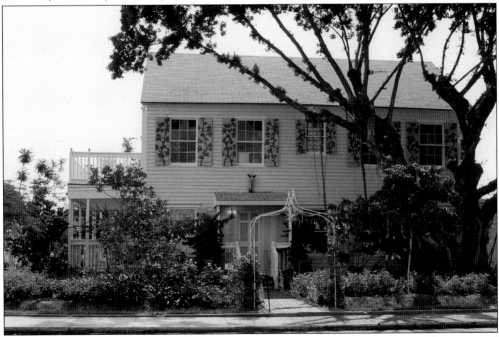

THE VINTAGE ROSE HOUSE. Formerly the Casebolt residence, this house was totally renovated and now houses an eclectic mix of gift-shop items. (Courtesy of Tamelyn "Tammy" Sickle.)

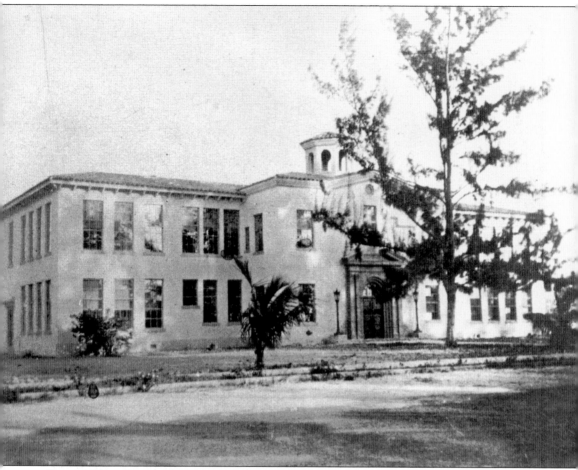

Delray High School. Built in 1925, the Delray High School is now the Crest Theatre. (Delray Beach Historical Society.)

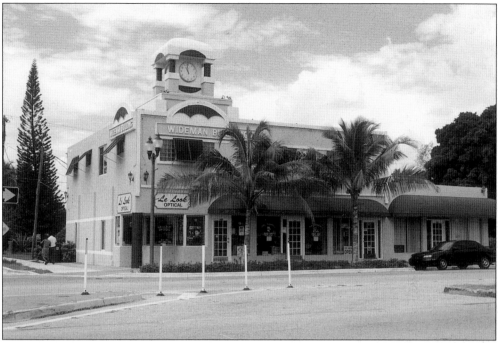

THE WIDEMAN BUILDING. Built in 1948 and renovated in the Art Deco style, the Wideman Building is located on Atlantic and 4th Avenues. (Courtesy of Vicente Martinez.)

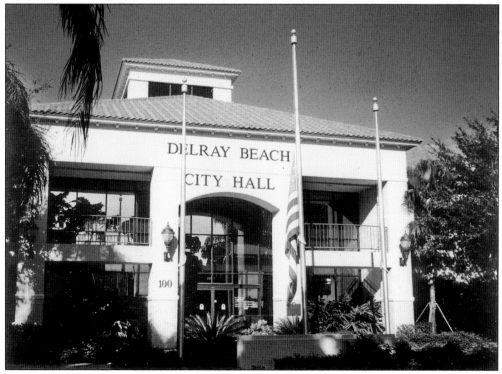

CITY HALL. The first city hall, completed in 1904 by the Ladies Improvement Association, also held concerts, plays, and discussions. Pictured here is city hall today. (Courtesy of Art Nejame.)

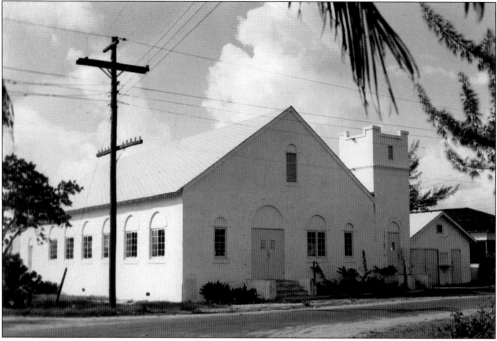

Mt. Olive Baptist Church. The first church organization was formed in Delray in 1896. This photo was taken in 1928. (Courtesy of Delray Beach Historical Society.)

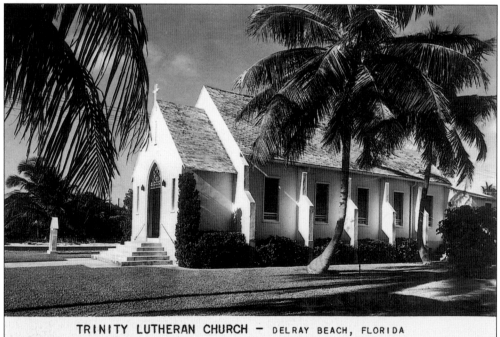

TRINITY LUTHERAN CHURCH — DELRAY BEACH, FLORIDA

Trinity Lutheran Church. Built in 1904, the Trinity Lutheran Church was redesigned in 1938 by Sam Ogren, a Delray Beach architect. Church services were held in the homes of Adolf Hofman and John Wuepper until the church was built. Members of the Wuepper-Miller family continue to worship at the church today. (Courtesy of Marcia and John Miller.)

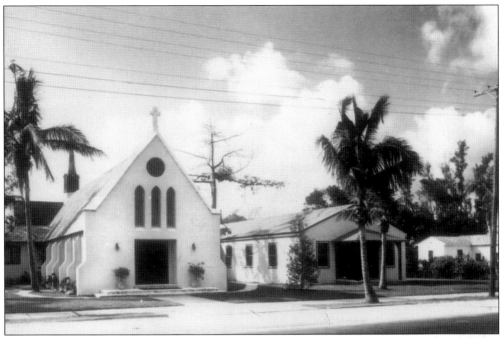

St. Paul Episcopal Church. This church was built in 1912. Members of the Jewish faith met at the church prior to building their synagogues. Also, bridge parties were a favorite pastime and were often held on Saturday afternoons at the parish house by groups of local women in the 1930s. (Courtesy of Delray Beach Historical Society.)

St. Paul AME Church Today. Organized in 1897 in a packing house and rebuilt in 1958, the second-oldest church was founded by black settlers of Delray Beach. It is pictured here at its N.W. 5th Avenue location. (Courtesy of the Delray Beach Historical Society.)

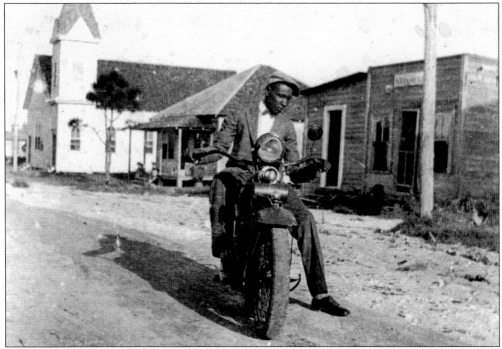

MAN ON BIKE IN THE SANDS AREA OF DELRAY, 1963. The Sands is the area where African-American settlers lived. Pictured on the left is Mr. Olive Baptist Church, the oldest church in Delray Beach. (Courtesy of S.D. Spady Cultural Arts Museum.)

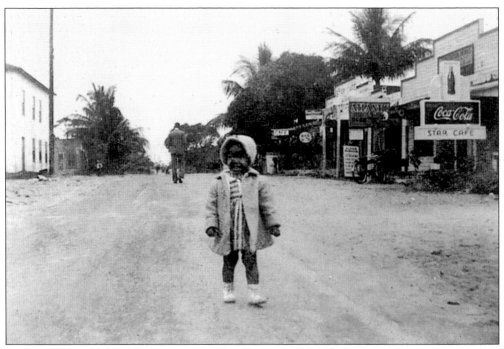

DELRAY BEACH'S N.W. 1ST STREET, AS IT WAS IN 1939. This area was known as the Sands area. Carol Jones continues to live in Delray Beach (Courtesy of H. Ruth Pompey.)

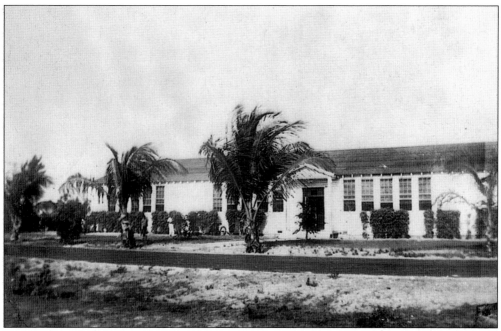

The Carver Elementary School. The Carver Elementary School held grades one through six. (Courtesy of H. Ruth Pompey.)

Carver High School. The Carver High School housed grades 7 through 12. (Courtesy of H. Ruth Pompey.)

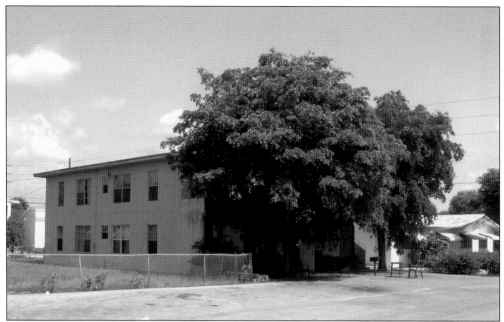

LaFrance Hotel. Built in 1947 to accommodate African-American musicians and entertainers, this was the only hotel in Delray Beach that would receive black guests. (Courtesy of Glenn Weiss.)

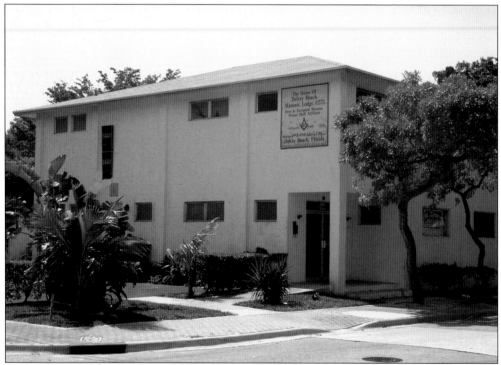

The Free and Accepted Masonic Lodge 275. The lodge was formed in 1899. The original building was constructed in 1904 and was used for social and civic events. (Courtesy of Glenn Weiss.)

THOWANAS HOTEL. The restaurant section of the hotel was built in 1947 and was a very popular eating place in the Sands area of Delray Beach until its closing in 1984. In 1961, Thomas Kemp, owner, built a hotel addition. (Courtesy of Glenn Weiss.)

BLACK HURRICANE SHELTER. This was known as the Red Cross Shelter for Blacks during the hurricane season. It is also known as the Robinson Refuge House. (Courtesy of Glenn Weiss.)

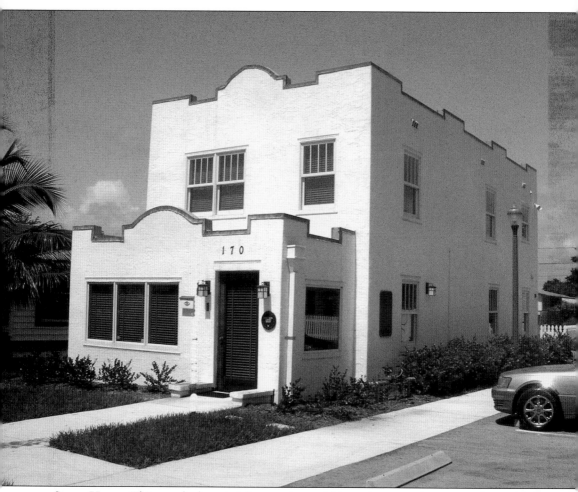

Spady House. This was the home of the prominent African-American business and civic leader Solomon D. Spady. The home has been restored and maintains its Mission-Revival style. Today it is the home of the S.D. Spady Cultural Arts Museum and EPOCH (Expanding and Preserving Our Cultural Heritage). (Courtesy of Glenn Weiss.)

Six

FESTIVE CELEBRATIONS

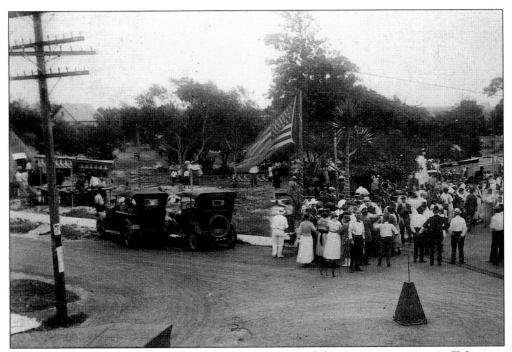

CARNIVAL ON ATLANTIC AVENUE, 1914. The town created their own entertainment. Television did not exist and outdoor activities were frequent. (Courtesy of Marcia and John Miller.)

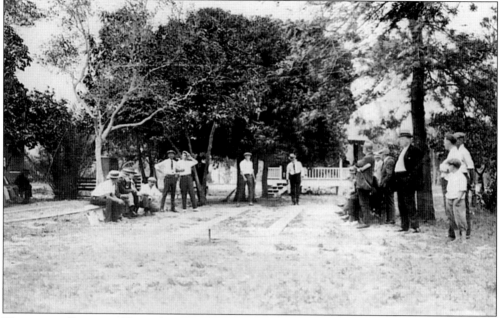

HORSESHOE CLUB AND BAND STAND. Throwing horseshoes became a "club" activity that took place near the Band Stand on the corner of N.E. 5th and Atlantic Avenues. This picture was taken *c.* 1913. (Courtesy of Marcia and John Miller.)

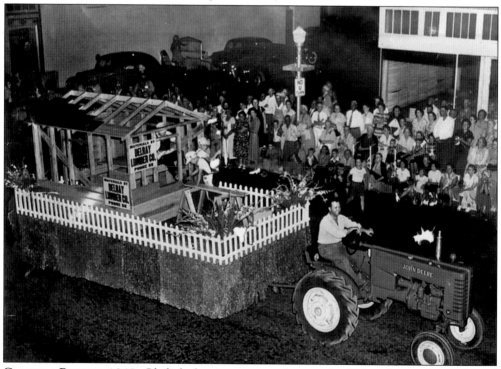

GLADIOLA PARADE, 1949. Gladiola farming was a major crop for Delray during the 1940s and 1950s. This image was taken at the Intersection of N.E. 2nd and Atlantic Avenues. (Courtesy Delray Beach Historical Society.)

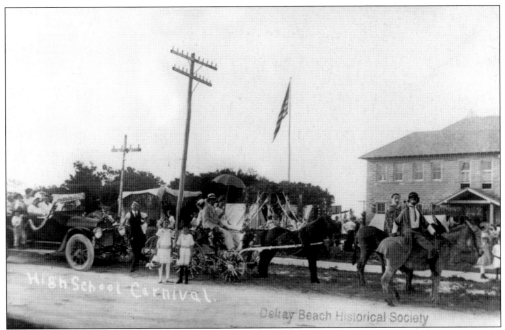

HIGH SCHOOL CARNIVAL, C. 1915. A carnival was held in front of the school building built in 1913, now the Cornell Museum. The couple in the car is identified as Lloyd Laton and Maxine Chastin. (Courtesy of Delray Beach Historical Society.)

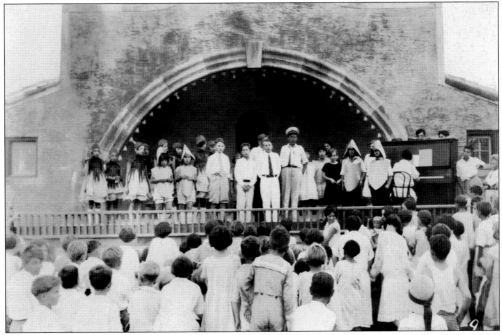

MAY DAY, C. 1920. N.E. 7th and Atlantic Avenues were the sites for the annual May Day festivities. These children are performing at what is now Veterans Park. (Courtesy of Delray Beach Historical Society.)

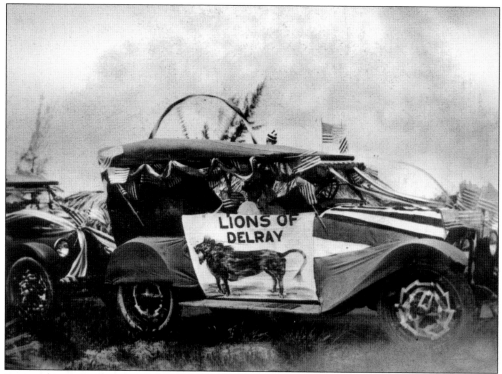

Fourth of July Parade. A car is decorated with "Lions of Delray" as part of a Fourth of July parade held in the early 1900s. This club was formed to help the blind. (Courtesy of Delray Beach Historical Society.)

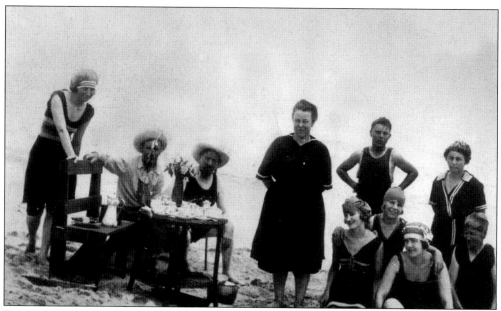

Beach Party, 1918. Picnics were organized at the beach. The early settlers created their own entertainment, oftentimes centered around beach activities. (Courtesy of Delray Beach Historical Society.)

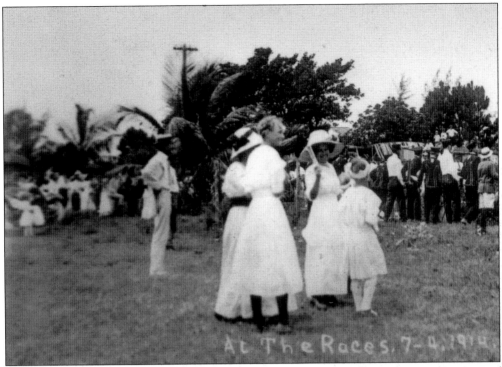

A Day at the Races. These spectators are watching horse races on July 4, 1914. (Courtesy of Delray Beach Historical Society.)

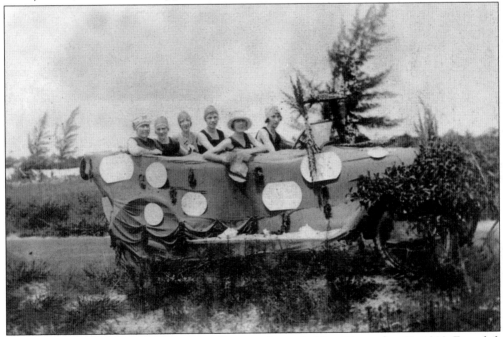

Armistice Day Parade. The Armistice Day parade was held on November 11, 1919. From left to right are Addie Sundy, Sadie Godbold, Mae Cramp, Amanda Godbold, Sadie Sundy, and Florence Camp. (Courtesy of Delray Beach Historical Society.)

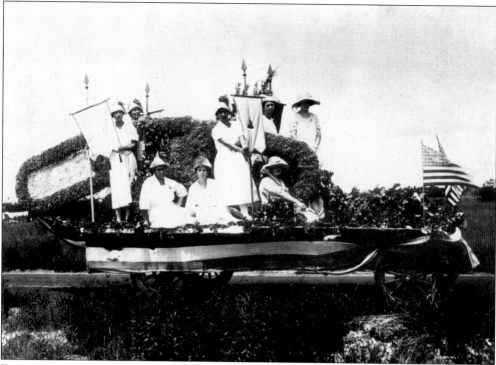

FOURTH OF JULY FLOAT. Parades were a large part of the July 4th celebrations. (Courtesy of Delray Beach Historical Society.)

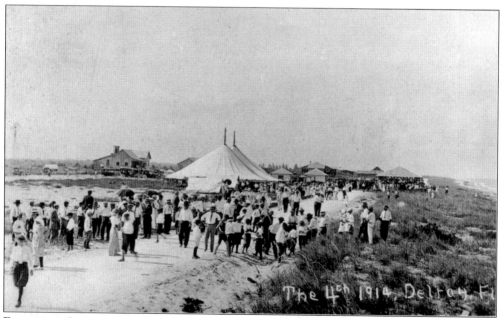

FOURTH OF JULY, 1914, NEAR THE BEACH. Celebrations of the Fourth of July centered on the beach with food, games, a parade, and firecrackers—just as it is today, except now there are more elaborate fireworks set off on a barge in the Atlantic Ocean. (Courtesy of Delray Beach Historical Society.)

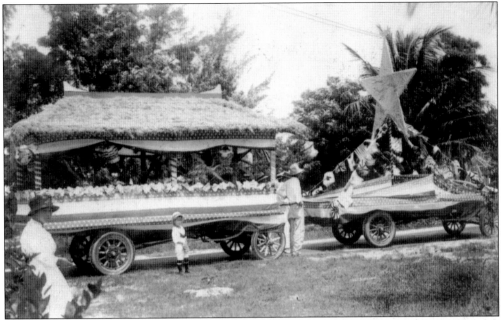

JAPANESE FLOAT, C. 1914. A Japanese float makes its way in a parade. Many of the Japanese came to Delray seeking their fortune in the field of agriculture, with many arriving in 1904. (Courtesy of Delray Beach Historical Society.)

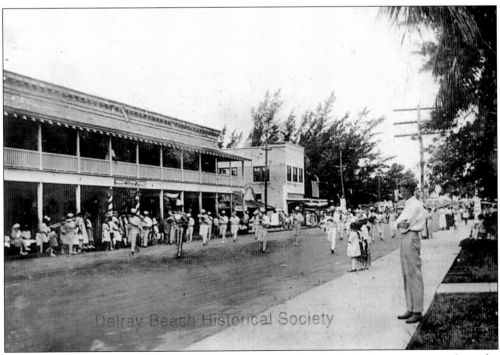

MARCHING BAND ON THE FOURTH OF JULY. This shot is on Atlantic Avenue, across from the George Building and the Cromer Building. The man watching is S. Kamikama of Yamato. (Courtesy of Delray Beach Historical Society.)

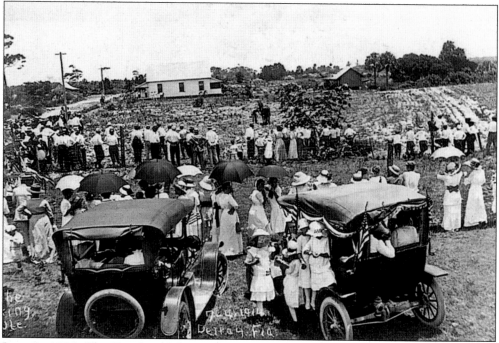

JULY 4, 1914. The Fourth of July was and continues to be a festive day in Delray Beach. (Courtesy of Delray Beach Historical Society.)

AN OUTING, C. 1920s. From left to right are unidentified, Jessie Johnson (Butts), Lillian Bradshaw (Cousins), Mary Catherine Murray (Cason), two unidentified people, and driving the car is Mildred Johnson. Mary Catherine Murray Cason was the mother of Mary Lou Jamison, present chairwoman of the Historic Preservation Board. (Courtesy of Mary Lou and Sandy Jamison.)

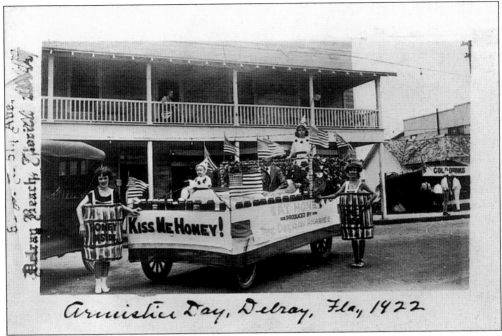

ARMISTICE DAY, 1922. Delray Beach was a small, but lively town. Parades were a major source of entertainment for families. (Courtesy of Delray Beach Historical Society.)

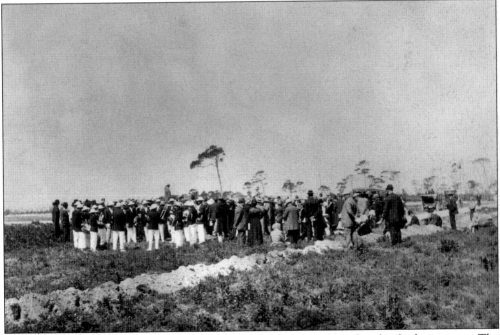

HORSE RACING FESTIVITIES, C. 1920s. Everyone in town would gather for the horse races. The races created a competitive atmosphere and people could try their luck while placing bets here. (Courtesy of Delray Beach Historical Society.)

REUNION OF NACIREMAS CLUB, c. 1960. NACIREMAS, "America" spelled backwards with an "s," was an organization for Negro soldiers. The United States Organization (USO) did not accept black soldiers. This club was their alternative USO in Delray Beach. (Courtesy of H. Ruth Pompey.)

ROOTS FESTIVAL PARADE, c. 1998. This parade is a part of the Cultural Festival, held annually with activities and events for community participation. The original black pioneer arrived in Delray in the 1800s. The agriculture industry was a major attraction. (Courtesy of Elizabeth Wesley.)

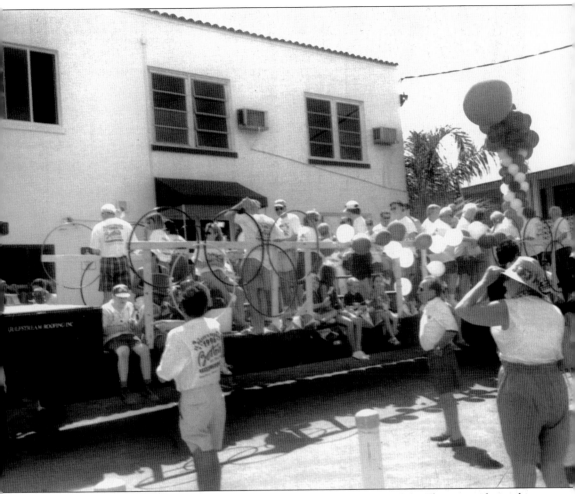

St. Patrick's Day Parade in Front of Boston's Restaurant, 1998. The original parade was initiated by Mr. Powers who carried a tiny pig, dyed green, down Atlantic Avenue. When animal lovers protested, the pig was no longer dyed. Today, the parade is still led by the Powers family and the pig is now carried on a truck. (Courtesy of Pepsi.)

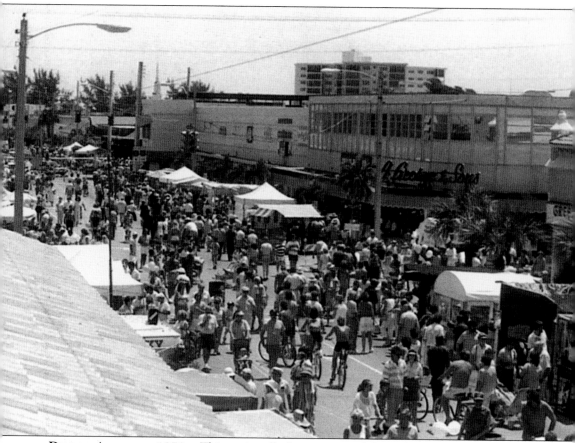

DELRAY AFFAIR, C. 1970S. This nationally known annual festival was once known as the "Gladiola Festival." In 1966 the name was changed to the "Delray Affair." (Courtesy of Greater Delray Beach Chamber of Commerce.)

Seven

PEOPLE OF DELRAY BEACH

SUMMER OF 1901. Shown from left to right are Nell the horse, Ethel Sterling Williams, Henry Sterling, three unidentified workers, Mary Elizabeth Sterling, and three Bahamian women who worked for the Sterlings. (Courtesy of Delray Beach Historical Society.)

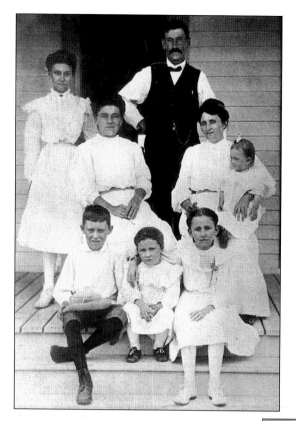

THE WUEPPER FAMILY. These early settlers arrived in 1902 from Bay City, Michigan, and realized that a Lutheran Church was needed. John and Margaret Wuepper were instrumental in building the Trinity Lutheran Church of Delray Beach. From left to right are (standing) Clara Wuepper Miller and John Wuepper; (seated in chairs) Margaret Wuepper and Margaret Zill Wuepper with baby Edna Wuepper; (seated on the porch step) Rudolf Wuepper, Margie Wuepper Lang, and Carolina (Lena Wuepper) Smith. They are pictured here *c.* 1906. (Courtesy of Marcia and John Miller.)

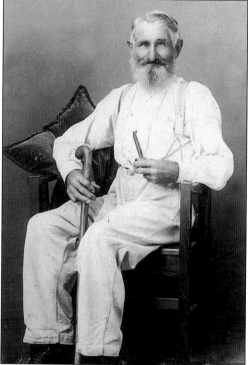

JOHN BLANK. Blank was one of the founders of the Trinity Lutheran Church. This picture was taken *c.* 1920. (Courtesy of Marcia and John Miller.)

WILLIAM JAMES AND GRACE FLORENCE CATHCART. Mr. Cathcart owned a lumber company. He purchased the Cathcart house in 1910 from J.R. Leatherman. His store sold household items, and his wife sold embroidery, lace, ribbons, etc. in the same building. Seminole Indians would come in to make purchases. Mr. Cathcart had the hides of reptiles, raccoons, and deer brought to him by trappers and hunters on his front porch. (Courtesy of Virginia Snyder.)

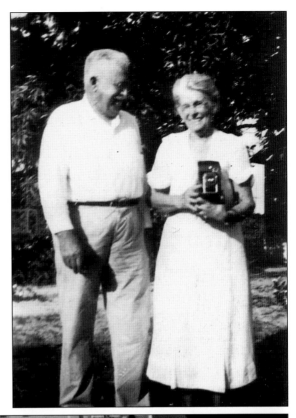

ROSS AND VIRGINIA SNYDER. Two loving couples have owned the Cathcart House. Mr. Cathcart bought it for his wife in 1910, and Virginia and Ross Snyder bought it in 1971. Mrs. Cathcart lived there for 50 years. Virginia and Ross still live there and have a life-estate agreement with Odette and Tom Worrell, the present owners. (Courtesy of Virginia Snyder.)

MARCIA AND JOHN MILLER. Many of the early settlers arrived in Delray from Bay City, Michigan, and their descendants live in Delray today. Pictured here is John Miller, a descendant of John and Margaret Wuepper, who were instrumental in organizing the Trinity Lutheran Church. (Courtesy of Marcia and John Miller.)

THOMAS KEMP, SHOWN IN THE UNIFORM HE WORE IN 1942 DURING WORLD WAR II. In the early years, Thomas Kemp owned a successful restaurant. He is the nephew of Ora Smith Wake, an opera singer, and James Luke Smith, a music teacher. Mr. Kemp lives on 5th Avenue, where he continues to operate a hotel. (Courtesy of Thomas Kemp.)

EDWARD GEORGE, C. 1942. The son of Abraham George was hired to swim out to areas around the Gulf in search of evidence of German submarines. The submarines slipped in and out of the coastal waters. George was nicknamed "Horsey." He was the husband of Mim George, who continues to live in Delray Beach today. (Courtesy of Sandy Simon.)

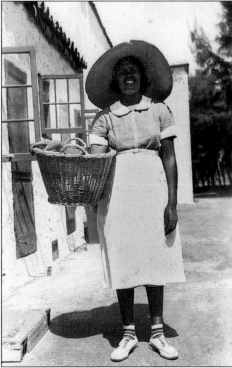

MARY LEE KEYS, FORMER LAUNDRESS FOR GULF STREAM GOLF COURSE, C. 1920s. Featured on Willard Scott's *Today* "birthdays" segment, Mary Keys continues to live in Delray and is now 102 years old. She is the mother of H. Ruth Pompey. (Courtesy of H. Ruth Pompey.)

H. Ruth Pompey, 1926, Age Three. Mrs. Pompey continues to be involved with the Delray Beach community today. (Courtesy of H. Ruth Pompey.)

C. Spencer Pompey, 1950s. The Pompey Park Community Center was designed by architect Roy Simon and is named in Pompey's memory. The future Pompey Amphitheater will be named in his memory for his contributions as an educator and political activist. (Courtesy of H. Ruth Pompey.)

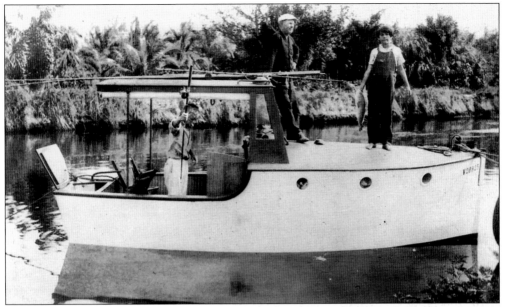

CAPTAIN AND MARIAN HAGER. The captain owned a charter fishing boat business in the early 1920s and lived at 1206 N.E. 2nd Avenue. (Courtesy of Delray Beach Historical Society.)

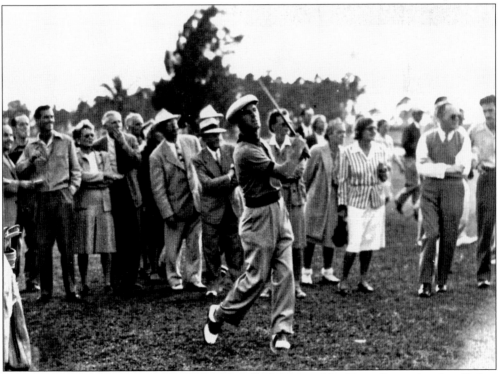

GOLF WITH TONY PENNA, c. 1947. A nationally known golfer, Tony Penna lived in Delray Beach. (Courtesy of Delray Beach Historical Society.)

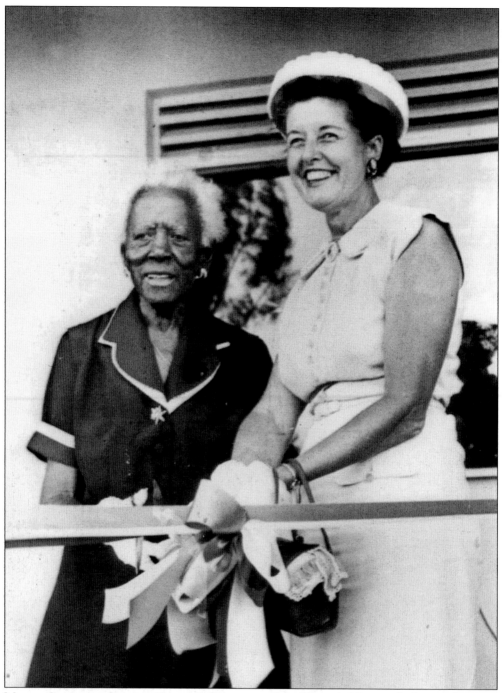

MAYOR CATHERINE STRONG, DELRAY'S FIRST AND ONLY WOMAN MAYOR. Catherine Strong is shown here with Francis Bright, the second teacher in Delray's African-American community. In 1956, Mrs. Strong, a councilwoman at that time, opposed an ordinance that segregated the beach and the swimming pool in Delray Beach. The ordinance stated, "No member of the Negro race shall go upon the beach or into the swimming pool." (Courtesy of Delray Beach Historical Society.)

Eight

VILLAGE BY THE SEA

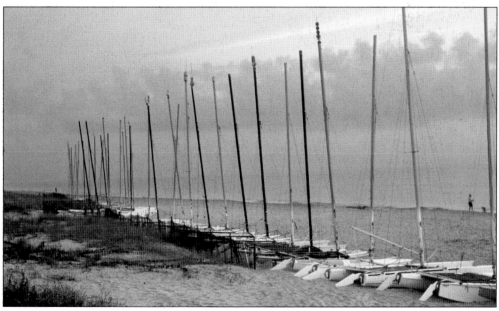

CATAMARANS, DELRAY BEACH. Many of the activities in Delray Beach continue to be centered around the beautiful beach area. (Courtesy of Pat Healy-Golembe.)

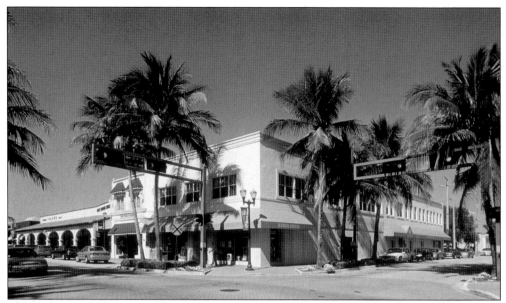

ATLANTIC AVENUE AT 4TH AVENUE. From right to left are Hubers Drugs, The Trellis Shop, Vince Canning Shoe Store, and Hands Book Store. Hands opened in 1934 and has expanded its service to include office supplies and stationary. (Courtesy of Pat Healy-Golembe.)

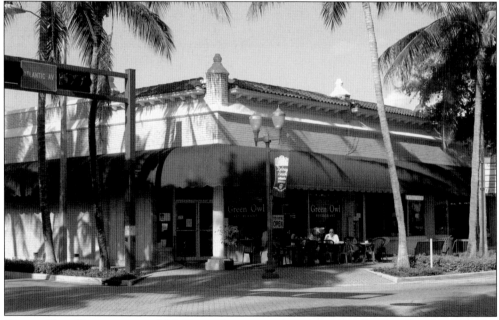

GREEN OWL RESTAURANT, 330 EAST ATLANTIC AVENUE. The George Family owns the landmark known as the Mercantile Building, which was constructed in 1928. Florida Power and Light were longtime tenants. (Courtesy of Pat Healy-Golembe.)

Looking South from Atlantic Avenue Bridge. Pictured from left to right are the Bar Harbour and the two Seagate Towers buildings. A few high-rise buildings were constructed in Delray Beach at the end of 1960s until the mid-1970s. After that, a height restriction was passed to control the height of high-rise buildings. (Courtesy of Pat Healy-Golembe.)

Sun Trust Bank. This corner of Atlantic Avenue and the bank parking lot east of the FEC Railroad tracks was the area where the Chapman House Hotel and the FEC Railway Station used to be. (Courtesy of Pat Healy-Golembe.)

COLONY HOTEL, A MEMBER OF THE HISTORIC HOTELS OF AMERICA. The Colony Hotel opened 1926 and was owned by Albert T. Repp. It was built with Mission-style architecture and was designed by Martin Luther Hampton. It is the only survivor of Delray Beach's eight resort hotels that were built before and during the Florida "boom"of the 1920s. It is presently owned by Jestena Boughton. (Courtesy of Pat Healy-Golembe.)

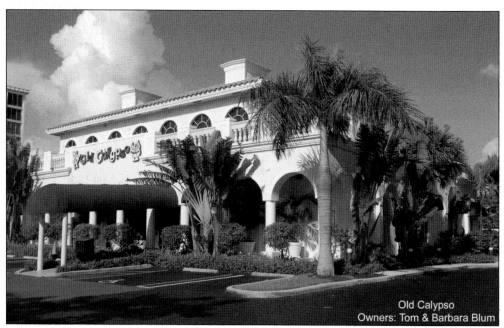

OLD CALYPSO. Built in 1998, the Old Calypso is a favorite dining spot on the Intracoastal of Delray Beach. (Courtesy of Pat Healy-Golembe.)

AURA RESTAURANT. Built in 1924 as the Barwick Building, the Aura Restaurant was located on E. Atlantic at the railroad tracks. L.L. Barwick, a prominent real estate broker, built his real estate office within 200 feet of the FEC so that land newly arriving land speculators would see his office first when getting off the train. (Courtesy of Pat Healy-Golembe.)

ATLANTIC AVENUE, FACING WEST. In 1915 the Delray Ladies Improvement Association worked for the beautification and widening of Atlantic Avenue to the ocean. Their organization has had a lasting effect on Delray Beach. This is Atlantic Avenue today. (Courtesy of Vicente Martinez.)

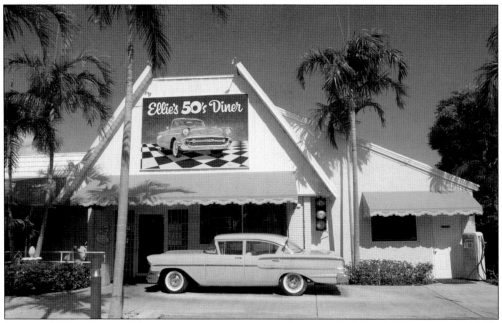

ELLIE'S 1950S DINER. This is a popular eating and meeting place decorated with 1950s memorabilia. (Courtesy of Pat Healy-Golembe.)

KENNETH R. BREMMER ANTIQUES, C. 1920S. The rear portion of this building was made of Old Dade County pine. The front was added on in the 1930s. (Courtesy of Pat Healy-Golembe.)

MEDITERRANEAN REVIVAL STYLE. The Scott House was built in 1925 by E.H. Scott, former mayor of Delray Beach. Mr. Scott also built the Seacrest Hotel where the Marriott is today. The Scott House was built from materials left over from construction of the Seacrest Hotel. (Courtesy of Pat Healy-Golembe.)

MONTERREY STYLE. This house was built c. 1934. It is a two-story building with low-pitched gable or hip roof. The second story displays a balcony cantilevered over the first floor and covered by the principal roof. (Courtesy of Pat Healy-Golembe.)

BUNGALOW STYLE. Built in 1939, this house is owned by the author. It is influenced by peasant huts in India. The design characteristics typically include porch columns and brick chimneys. (Courtesy of Pat Healy-Golembe.)

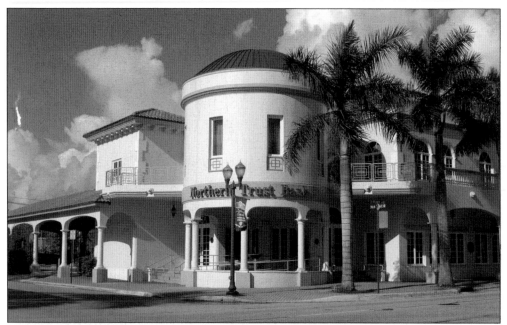

NORTHERN TRUST. This is the former site of the Patio Delray Restaurant. Charlie Herring, who had worked for Bill Kraus (owner of the Arcade Taproom), operated it. Both restaurants were landmarks and attracted customers and celebrities from throughout South Florida, especially during the winter season. (Courtesy of Pat Healy-Golembe.)

PETERS STONE CRAB, KNOWN AS THE ARCADE BUILDING. This building was constructed in 1923 by Samuel Ogren Sr., architect, in the Mediterranean Revival style. It has been called the "heart and soul of the Artists and Writers Colony," since members could often be found there. (Courtesy of Pat Healy-Golembe.)

FOUNTAIN AT ATLANTIC PLAZA. Alexander "Sandy" Simon, developer, located the fountain on the former site of Kentucky House Restaurant and Hotel, which was built by the Bradshaw family, who came to Delray Beach from Kentucky in 1912. (Courtesy of Pat Healy-Golembe.)

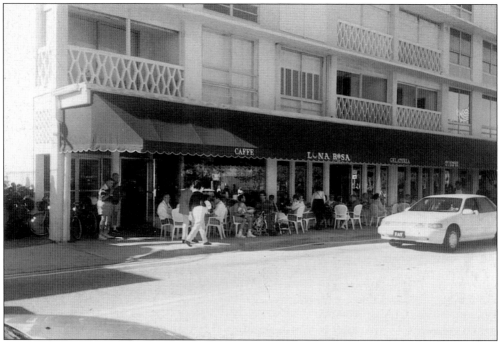

CAFÉ LUNA ROSA. In 1935 officials decided to open Ocean Boulevard all the way down to Boca Raton. The roadway had been washed away during a hurricane. Today, Café Luna Rosa, opened in 1994, typifies the beachfront outdoor restaurants. (Courtesy of Fran Marincola.)

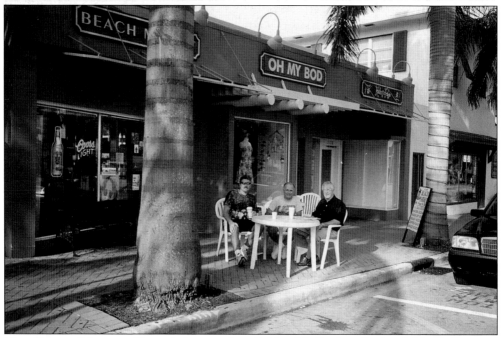

THE BEACH MARKET. From left to right, Bobby McCauley, Richard Nardiello, and Jack DeNiro enjoy their early-morning coffee ritual on Atlantic Avenue. (Courtesy of McCall Credle-Rosenthal.)

BEACHGOERS ON A1A IN FRONT OF BOSTON'S ON THE BEACH RESTAURANT. This area had once been destroyed by hurricanes. It is now the scene of beach activities and restaurants facing the beach. (Courtesy of Pat Healy-Golembe.)

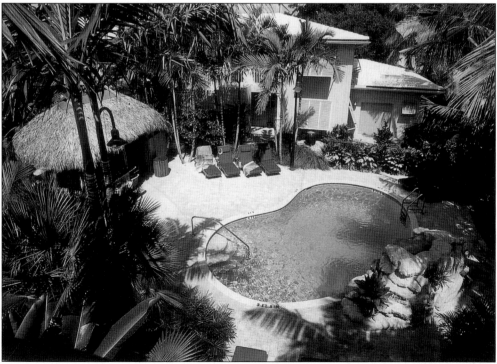

CRANE'S BEACH HOUSE. Built in 1955, Crane's Beach House was voted as one of the most romantic hotels in Palm Beach County. It is within walking distance of the beach and features a tasteful interior design by Cher Crane with a mixture of tropical country-club and relaxed house-party ambiance. (Courtesy of Juliana Del Flore.)

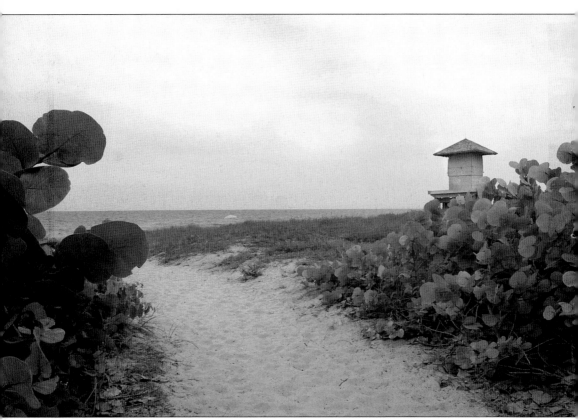

"Sea grape" Entrance to the Beach. This Village By the Sea, Delray Beach is nestled between the Sea Grape–filled beaches on the east and farmlands on the west. (Courtesy of Pat Healy-Golembe.)